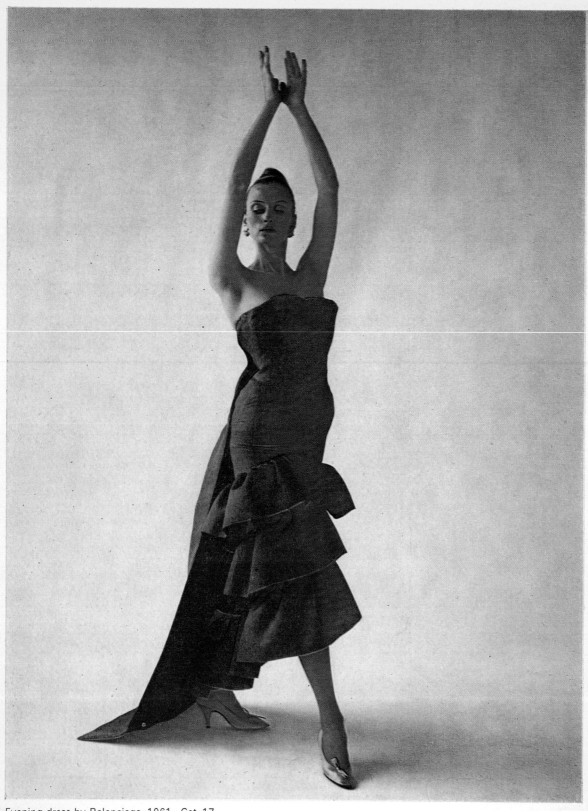

Evening dress by Balenciaga, 1961. Cat. 17

Victoria and Albert Museum

Fashion
an anthology
by Cecil Beaton

Catalogue compiled by
Madeleine Ginsburg

London 1971

Catalogue of an exhibition at
the Victoria and Albert Museum
October 1971–January 1972
Second (amended) impression

Exhibition designed by Michael Haynes

Catalogue designed by HMSO/Adrian Young

Price 30p
SBN 901486 40 X

Printed in England for HMSO at The Baynard Press
Dd 646487

Foreword

All outstanding art collections are informed by
individual taste. It was therefore with the utmost
pleasure that I welcomed an offer from Cecil
Beaton to form, on behalf of the Museum, a
collection of those dresses that he most admired.
Thanks to his persuasive enthusiasm and to the
generosity of the contributors, the collection,
which will eventually be shown in a permanent
setting in the Costume Court, is large and
representative. Only a third of the dresses in it
are included in the present exhibition. For this
incomparable enrichment of the Museum's
resources, whole-hearted thanks are due to
Cecil Beaton, the only begetter of the project,
and to the donors of the dresses, whose names
appear in the catalogue. The installation is due
to Michael Haynes, and the catalogue entries
are the work of Mrs Madeleine Ginsburg, who
wishes to record her indebtedness to the makers
of the dresses, and especially to Mademoiselle
Yvonne Deslandres of the Paris Centre de
Documentation de Costume and to Miss
Marjorie Dunton of the Syndicat d'Initiative de
la Couture Parisienne.

John Pope-Hennessy
Director

Fashion
an anthology
by Cecil Beaton

Introduction

By Cecil Beaton

Fashion is a mass phenomenon, but it feeds on the individual. The true representatives of fashion are often those whose surprising originality leads them to a very private outward expression of themselves. In some given decade they appear somewhat outré, they may border on exhibitionism, or even eccentricity, but their means of self-expression curiously corresponds to a need in others who, in a modified way, copy them. Thus they create taste.

But how can taste be defined – or confined? Although its basic rules are implicit, it is one big contradiction. Taste is dependent on environment – where you happen to be – upon the outside world and what it imposes, and on the needs. Only a few garments seem to keep their validity for ever: the sari in India, the sarong in Tahiti, the dirndl in Austria, tweeds in Scotland. But in most countries of the world today there is not only no national costume, but no consistency of look. We get into a car, airplane or helicopter, and go forward into space where people have never been before. Even if we cannot travel, with television and other modern media, we cover so much ground and see things from all over the world. This is a new age of speed which is apt to make us restless; perhaps that is why, for example, there have been such frequent changes in dress in recent years.

Change is brought about by glut, by over-use, but that is an exterior reaction; it is the inner reactions that are important. In the seventeenth and eighteenth centuries, fashions were more stable; perhaps fifty years elapsed before any new ideas took root: now this happens continually. Yet they always come as a surprise; to the older, and more stuck-in-the-mud, they can be dismaying: to the young they are pleasant. Surprise is necessary to us: it enchants us and has for all time. The development of constant growth needs changes; recently they have become so rapid and complete that 'last season's line' appears archaic. Overnight a woman must throw away her too long or too short skirt; everything is expendable.

Yet, paradoxically, never before has individual taste been given such an opportunity to show itself. Forty years ago people were considered barmy if they chose clothes outside the restricted orbit of accepted taste. Today everyone is allowed to put on what they like: anything goes except boredom. Young men appear at dinner in eighteenth century courtiers' uniforms. Walk along any urban street or country lane and you will see Hiawathas, cow-boys and girls, Victorian misses, Edwardian ball-dancers or 1940 tarts. No one stares. There is no reason for fancy dress parties any more when every day can be used for 'dressing up'. Only a few remaining obsolete schoolmasters inveigh against Renaissance or Cavalier hair styles.

All taste is in embryo at one point; seeds are sown, but they must await the sunshine to grow. An original idea is born, lies dormant; then suddenly it comes into flower because the time is right. It is to those who are responsible for this creation that, in making this anthology, I wished to pay homage. Who would these originals be? Ideally I would like to collect something that belonged to Queen Alexandra. She was ineffably chic. Her silhouette was that of a figurine from Knossos with her hourglass-corset and high, tightly-packed hair, and her late-in-life use of spangled and black sequin daytime coatees was certainly original. And Lily Elsie's huge black 'Merry Widow' hat, worn with a gossamer evening dress, was a landmark. Mrs Lydig's first 'backless' ballroom gown

caused a sensation, as did her fantastic shoes with long tongues of medieval brocade. Certainly of this eclectic company is Lady Ottoline Morrell, who wore picturesque Velasquez Infanta skirts in the 'twenties, and Edith Sitwell, whose pre-Raphaelite silks were embroidered with vivid flowers. It was obvious that there would be difficulties in finding this sort of ephemera.

Soon I realized how little had survived jumble sales, thrift shops, village pantomimes, or cast-offs to poor relations and impoverished governesses. Few people today possess attics for storage, or even cupboard space. I comforted myself that an anthology, by its very nature, is always incomplete.

Beginner's luck did not escape me. I even began to wonder why on earth I had not embarked upon this search many years before.

After the first enthusiasm of friends bearing gifts, there were disappointments. The theatre possesses few relics that do not now appear lifeless after the fall of the final curtain. Nothing was available to indicate the *panache* of Mesdames Margot Asquith, Daisy Fellowes, or the houses of Louise-boulanger and Cheruit. No trace could be found of Miss Ida Rubinstein's or the Marchesa Casati's leopard skins. A multimillionaire in Chicago, whose wife, recently dead, had been famous for her clothes, and whose mother before had created a niche in social history through the splendour of her apparel, decided that, although many of their dresses, dating from the 'nineties, had not even been taken out of their Paris boxes, they were of too private a nature. So he committed the great act of vandalism by burning the lot six weeks before I approached him.

By degrees my original intention changed somewhat, and I started to look for examples of the best in the field of dressmaking. How lucky I was to come by a Poiret dress made of one piece of oyster satin – as up to date as it was sixty years ago, a great black bishop's cope of Balenciaga with only one seam, and Mizza Bricard's fantastic hats for Dior. Soon my choice of a dress was influenced by history and origin: by its maker, its owner, or by the circumstances in which it was worn. It was pleasant to discover how many of the present-day creators – in England as well as abroad – were willing to help in seeing that their work was represented, some even specially making items which they felt might be definitive examples of their talent. Perhaps an exhibition of these clothes might be particularly interesting at a time when it is said that 'high fashion' is a dying concern.

Young London designers, without allowing the commercial to destroy their creative talents, mass-produce fashions by modern means that have ricochetted throughout the world. 'Pop' art and comic-strips have brilliantly inspired them; they, in turn, have influenced some of the top Paris designers, who it is difficult to deny remain unassailable. Some of these, perhaps only temporarily, have abandoned their former tenets of refinement and style in favour of the consciously 'kitch' and 'courci'. They may have heard that elegance has become a dirty word. According to the dictionary, elegance means proportion, discrimination, refinement. Elegance, of necessity, must change its concept. When rules become too rigid they should be broken. There is always a moment when 'good taste' becomes dead: what has before been considered 'bad' is suddenly found to be invigorating. Fashion today has little to do with *la mode*, and the 'tacky' is often accepted as an essential part of the necessary 'total look'. It can be fun. But that the young should try to re-create the

odious vulgarities of Hollywood in the Ginger Rogers epoch makes one wonder if there is not a poverty of invention today? Is fashion suffering from a lack of culture? However, whatever one may think of the throwback to bad movie costumes, the recent revolution has made a mockery of former notions of taste: it has certainly succeeded in making the lady in 'becoming' brim and draped beige appear as a caricature of a dowager in a long-forgotten drawing-room comedy.

In fact, most 'expensive' clothes have lost their aura of mystery. There was a time when certain women boasted, 'I'm going to wear my new Balenciaga tonight'; and thus they cheapened themselves. Today the great variety of clothes shows that the answer to taste is not to be found in what three or four fashion-houses try to impose. The snobbery of the label inside the coat is out. The expression of people's taste today is simply to show by clues and hints that this is what they like. They tend to choose clothes which can be considered more in the nature of a personal 'find'.

Few people today need feel they cannot afford fashion, for it is everywhere and every-one's personal choice is accepted. The young do not like visible signs of possessing money. Although some probably lead a life that costs far more than their father's did, and they may have the most expensive cars and hi-fi equip-ment, they do not want an object to be theirs merely because it is a very good and costly possession. They balk at that.

Fashion today is doing something that has never been done before: it is going for information and inspiration to the street and to the sports field. Perhaps it is the workman in his boiler suit, the garage mechanic, the welder on the building site, or the footballer who can provide the 'look'

for our present-day needs. There are, no doubt, complicated reasons why the paragon of fashion should have changed from the 'beau' to the 'tough'; but there is no denying the simple fact that it was the 'teddy boys', by doing what we would all like to do — 'expressing themselves with a splash' — who led the way from the anonymity of the average Englishman in his pin-stripes, shapeless mackintosh and bowler, to bold colours, unusual materials and elaborate hair styles. They it was who redefined elegance; if fashion is to exist, elegance will always remain. Mediocrity and safety first, at last, is no longer the mainstay, and nobody is any longer afraid of making individual gestures.

'Today' will be considered outstanding in fashion, for we have achieved a freedom that is a reflection of individuality. Everything is per-mitted, and everything that goes beyond the simple fact of food, shelter and clothing is a luxury. Our whole civilization has become a luxury, and it is that we must defend; we must go on living as though Armageddon were not at hand. We must cultivate our sensibilities, and encourage the arts, even if the world blows up tomorrow. We should be like the Duchess of Malfi and 'grow fantastical on our death beds.' 'Our duty', said Christian Dior, 'is not to yield, but to be an example, to create in spite of everything.'

Donors

H.M. Queen Elizabeth II
H.R.H. The Princess Anne
H.M. Queen Elizabeth The Queen Mother
H.R.H. The Duchess of Kent
H.R.H. Princess Alexandra, The Hon. Mrs Angus
 Ogilvie
H.R.H. The Duke of Windsor

Lady Abdy
Madame Agnelli
Mrs Joseph Alsop
An anonymous lady
The Art Students League (USA)
The Hon. Mrs J. J. Astor
The Earl and Countess of Avon
Miss Philippa Barnes
Mr John Bates
Lady Beit
M. Berman, Ltd
Biba
The Countess Bismarck
Mrs Alfred Bloomingdale
The Viscountess de Bonchamps
The Hon. Mrs Raymond Bonham Carter
Mrs Frederick Brisson (Miss Rosalind Russell)
Mrs David Bruce
Mr Edward Burns
Her Excellency Madame Miguel Angel Carcano
Monsieur Pierre Cardin
The late Miss Margaret Case
Madame Catao
Countess de Chauvignac
Sybil, Marchioness of Cholmondeley
Mr Raymond (Ossie) Clark
Miss Sybil Connolly
Lady Diana Cooper
Her Excellency Madame de Courcel
Viscountess Cranborne
The Lady Delamere
Mrs Leo D'Erlanger

Duchess of Devonshire
Countess of Drogheda
Stella Lady Ednam
Erté
Mr Aubrey Esson-Scott
Mr Kaffe Fassett
Mr Michael Fish
Mrs Ian Fleming
Foale and Tuffin
Miss Lynne Fontanne
Dame Margot Fonteyn
Miss Ruth Ford
Mr John Fraser
Miss Gina Fratini
Mr Freedom
Princess Irene Galitzine
Mr Bill Gibb
Baroness Antoinette de Ginsbourg
Lady Gladwyn
Lady Glendevon
Mrs Paul Gregory
Miss Joyce Grenfell
Madam Grès
Mrs Loel Guinness
Mrs Alec Hambro
Hanson Inc.
Earl of Harewood
Miss Honey Harris
Mrs Jack Heinz III
The Hon. Mrs Antony Henley
Mrs Charlton Henry
Miss Audrey Hepburn
Lady Elizabeth von Hofmannsthal
Miss Jane Holzer
Mrs Matilda Etches Homan
Madame Martinez de Hoz
Mr Charles James
Mrs William King
Miss Ann Klein
Mr Harold L. Knapik

Miss Eleanor Lambert
Mr Vern Lambert
Viscountess Lambton
Mrs Nancy Lancaster
Mr Robert Lavine
Earl of Lichfield
Lady Lloyd
Miss Anita Loos
Mr Rupert Lycett-Green
Mrs Rory McEwen
Mrs Graham Mattison
Mrs Paul Mellon
Mr Michael
Mrs Gilbert Miller
Mrs Simone Mirman
Miss Nancy Mitford
Mr Curtis Moffat
Miss Marianne Moore
Miss Jean Muir
Miss Cathleen Nesbitt
Mr Stavros Niarchos
Norman Norell Inc.
Mrs Peter Palumbo
Countess of Pembroke
Madame de Callejon Propper
Miss Mary Quant
Princess Stanislaus Radziwill
Madame Lilia Ralli
Mr Edward Rayne
Mrs Charles Revson
Monsieur Robert Ricci
Baroness Alain de Rothschild
Baroness Elie de Rothschild
Baroness Philippe de Rothschild
Mrs Walther Moreira Salles
Monsieur Yves Saint Laurent
Madame Elsa Schiaparelli
Mrs Pierre Schlumberger
Mr Michael Sherard
Miss Jean Shrimpton

Sills & Co.
Mr Francis Sitwell
Lady Smiley
Mrs Smith
Miss Muriel Spark
Baroness Spencer-Churchill
Mr Geoffrey Squire
Madame Marcella Traballesi
Lady Ann Tree
Mrs Ronald Tree
'Twiggy'
'Valentina' (Mrs George Schlee)
Lady Frieda Valentine
Mrs Gloria Vanderbilt Wyatt Cooper
Madame Vernier
Monsieur Roger Vivier
Mrs Diana Vreeland
Mr David Watts of Jaeger
Ava Viscountess Waverley
Lady Victoria Wemyss
Duchess of Windsor
Mrs Frank Wooster
Miss Irene Worth
Mrs Charles Wrightsman
Mr Kansai Yamamoto

Loans from
 Mr Quentin Crewe
 Lord Mountbatten
 Museum and Art Gallery Northampton

Acknowledgments

We acknowledge with thanks the help in the
preparation of this exhibition and catalogue of
the donors, makers, designers, those mentioned
in the Foreword and:
Mrs Alison Adburgham
Miss Janet Arnold
Miss Gloria Barnet of Charles Jourdain
Mr Budgen of Harvey Nichols
Mr Nino Caprioglio
Mrs Ernestine Carter
Mr John Cavanagh
Mrs Clement
Daily Telegraph Reference Library
Mr Stanley Hall of Wig Creations
Miss Eleanor Lambert
Mr Kenneth Lane
London College of Fashion, Library; Miss
Coghlan and Miss Pugh
London College of Fashion, the School of
Hairdressing, Mrs F. Reed and Mrs Jarvis
Mr Adrian Mann
Mr Michael Pope, Wimbledon School of Art
Mrs Anne Price
Mrs May Routh
Mademoiselle Henriette Vannier
Victoria and Albert Museum: Department of
Textile Conservation, Mrs Scott, Mrs Judith
Doré, Miss Nancy Duncan and staff;
Department of Education, Mrs Jane Connell,
Mrs Celia O'Malley, Mr Geoffrey Squire;
Department of Textiles, Miss Avril Hart,
Miss Lydia Jonasson and staff
American and *British Vogue:* Miss Beatrix Miller,
Mrs Arabella von Westenholz, Mrs Sheila Wetton

Exhibition Credits

Consultants and Dressers: Neil Grant, Earle Kyle, Michael Southgate, Cliff Wilson
Construction: Brian Daniels
Settings: *Twenties section;* J. Anthony Redmile: *Balenciaga section;* background from photograph of Gaudi's Sagrada Familia, Gradations of shadow and light on the interior structure of the unfinished facade from *Gaudi the Visionary* (by Clovis Prevost), published by Patrick Stephens Ltd:
Dior section; fittings from Dior Salon, London:
Schiaparelli and English Contemporary section; backgrounds painted by Patrick Stackhouse:
Royal section; fabrics designed by Michael Szell for the Investiture of Prince Charles at Caernarvon Castle
Fashion and Display Consultant: Vern Lambert
Mannequins: Barway Mannequins; Contour Displays: Derek Ryman
Mannequins: Adel Rootstein; Schiappi of Zurich, London
Schiaparelli Mannequins by Janet Benham, Andrew Logan, Anthony Redmile
Wigs: Leonard; Vidal Sassoon; Wig Creations
Lighting: Arnold Dover; Perspex from Imperial Chemical Industries
Turntable Units: British Turntable Company; Display and Movement Ltd
English (early Victorian) cut glass chandelier lent by Miss M. E. Crick, Kensington Church Street
Perfume: courtesy of: Balenciaga, Schiaparelli, Patou, and E. M. Douek; Yves St Laurent, Dior, Grès, and Charles of the Ritz; Nina Ricci, and Shulton of Great Britain; Dessès, and De Payot; Givenchy, and Givenchy, London; Norman Hartnell; Balmain, and Revlon; Chanel
Shoes: Edward Rayne from Rayne Shoes Ltd.

Catalogue

The catalogue entries include notes on the
designers of the complete outfits in the exhi-
bition but not on the designers of accessories.
Quotations in the main are restricted to those
made by designers on their own work. The
dating of the clothes, wherever possible, has
been checked with the house concerned.
**The catalogue entries and list of donors
are complete to mid-August 1971. Items
subsequently received are included in
the list of Additions.**

All photographs and drawings in this catalogue
are by Cecil Beaton except those on pages 6,
17, 21, 24, 26, 37, 42, 43, 52 and plates
1 and 4.
We are grateful to the *Sunday Times
Magazine* for permission to reproduce the
frontispiece and plates 2, 3, 5, 6, 8a, 9b, 10,
12a and 16.

ADOLPHO (USA): Adolpho Sardinia

Trained with Balenciaga and started as a designer for hats and clothes in New York, 1962.

1 **Patchwork evening outfit.** USA. Adolpho, 1967: a long mid-19th century cotton patchwork *skirt* worn with a beige cotton *blouse* and black and white striped ribbon *ruff* and *sleeve bands*.
Worn and given by Mrs Gloria Vanderbilt Wyatt Cooper

2 **Patchwork silk evening outfit.** USA. Adolpho, 1967: a long *skirt* of random patchwork worn with a pink cotton *blouse*, the sleeves of which are trimmed with maroon ribbon bows, worn with a patchwork *ruff* and *broad belt*.
Worn and given by Mrs Gloria Vanderbilt Wyatt Cooper

HARDY AMIES (England): Edwin Hardy Amies

Born 1909, trained at W. & T. Avery Ltd, Birmingham 1930–34; trained and was managing designer at Lachasse of London, 1934–39. In 1946, he opened his own couture house at 16 Savile Row. His clothes are notable for their refinement and he has been Dressmaker by Appointment to Her Majesty Queen Elizabeth II since 1946.

3 **Cream silk evening outfit.** English. Hardy Amies, November 1959: a sheath, embroidered at hip with silver and crystal bead embroidery worn with a matching short waisted *jacket* with an embroidered border.
Worn and given by Lady Delamere

4 **State evening dress.** English. Hardy Amies, May 1965: it is made from turquoise double-faced satin, the bodice entirely embroidered in rose cut diamanté and white china beads in a design suggested by the rococo decoration by Cuvilliés of Schloss Augustusburg, where the reception was held. The colours of the dress, blue and white, recall those of the family by whom it was built. The dress has a fitted bodice and a slightly gathered skirt.
Worn by Her Majesty the Queen at the State Reception at Schloss Augustusburg in Brühl, West Germany, 18 May 1965, and given by her

ANNACAT (England)

Was opened by Janet Lyle and Maggie Keswick in 1965. After the latter left in 1967 Janet Lyle carried on alone until she was joined by Leslie Poole in Autumn 1970.

5 **Printed cotton evening dress.** English. 'Annacat 1970: a puffed sleeve *jacket* and *skirt* trimmed with 'broderie anglaise'.
Worn and given by Mrs David Bruce

MADAME ASTIER (England)

6 **Scarlet evening outfit.** English. 1962: a *gown* of velvet with hanging sleeves of matching satin (Madame Astier) worn with a *hat* of cloth of gold (Whiteleys) and *shoes* of gold kid (Selby Ltd).
Clothes worn by Edith Sitwell at the Royal Festival Hall on 9 October 1962 at a celebration organized by the Park Lane Group to celebrate her 75th birthday and given by Mr Francis Sitwell

BALENCIAGA (France & Spain): Christobal Balenciaga

Spanish born couturier, opened his Paris salon in August 1937, closing in March 1968. His clothes have an incomparable stark elegance of line and economy of cut. He prefers black or clear bright colours for evening.

7 **White jacket.** French. Balenciaga, about 1948: of duchesse satin entirely covered with small loops of white beads. It is fitted, has a small roll collar and long tight sleeves.
Worn and given by Madame Miguel Angel Carcano

8 **Black evening dress.** French. Balenciaga, about 1948–50: made from organdie with self-coloured flock flowers. The dress has a low round neck, elbow-length sleeves and is Princess-line with a full skirt.
Worn and given by Mrs Loel Guinness

9 **Beige, silver embroidered evening dress.** French. Balenciaga, no. 85, August 1959: it has a high round neck and is sleeveless. The slightly full skirt is gathered on to a high waistband. Worn with matching *handbag* with square flap (Balenciaga), *shoes* of buff silk with diamanté clips (Saks, Fifth Avenue), *gloves*, long, of cream stretch satin (Christian Dior).
Worn and given by Mrs Charlton Henry

10 **Black lace frilled evening coat.** French. Balenciaga, 'Le Mouton Noir' 1960: full length, semi-circular and entirely covered with flounces: worn wrapped across to one shoulder. With it are white satin *trousers* and *shoes* (Vivier), with a flower trimmed chisel toe and high stiletto heel.
Worn and given by the Baroness Philippe de Rothschild

H.M. The Queen in state evening dress by Hardy Amies, 1965. Cat. 4. Courtesy of Robb and the *Daily Express*

DAILY EXPRESS

No. 20,205 WEDNESDAY MAY 19 1965 Weather: Rain

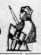

3,000 guests battle to see her at the banquet

THE QUEEN DAZZLES THEM

From COLIN LAWSON
Bonn, Tuesday

GERMANY was stunned tonight by a scene it scarcely dreamed of—the Queen entering a fairy castle on the Rhine in dazzling array.

TV cameras took the picture into millions of homes, and, illegally, into East Germany.

A PICTURE of the Queen arriving for a state banquet at the Schloss Augustusburg wearing a glittering turquoise and white gown with pearl and diamond tiara.

A PICTURE that would have thrilled London.

A PICTURE that had the Germans—used to being ruled by dull, if dangerous, men—in an ecstasy.

Smiling

The Queen was still smiling gaily too after the long, tough first day of her visit. Before her now was a "political" speech to make at dinner, and a vast reception.

This was no martial affair (Prince Philip had swiftly changed from his R.A.F. uniform). It was the Queen's night, a night for every frau and fräulein to savour, a night for the men to sit back and wonder.

As 100 special guests dined upstairs, there was near-chaos below with 3,000 people arriving for the reception, all pushing and shoving for vantage points on the edges of the red carpet along which the Queen would pass.

After dinner there came a "Sssh" as the Queen descended the staircase.

On a long terrace, silk-roofed, people clambered on chairs to peer through the salon windows.

Inside, aisles were cleared by protocol officials and through the divided ranks a cool, supremely confident and smiling Queen passed slowly, pausing to talk occasionally to a guest.

Down the full 400 yards she went, paused, turned, and came back, with Prince Philip following.

Trouble

The Prince's German, it turns out, is not so hot. A number of times he opened conversations with German guests but had to lapse into English or call for an interpreter.

His favourite targets were Iron Cross-bearing veterans wearing white tie and tails.

To one he said: "*Waren Sie Soldier?*" ("Were you a brave soldier?") The ex-officer he was speaking to was somewhat surprised and said: "Who can say?" The interpreter had to be consulted.

One of the principal guests was Prince George of Hanover. Once the Queen and Prince Philip had asked to be invited was Mr. Kurt Hahn, first headmaster of Salem and Gordonstoun schools.

After the reception the Queen and Prince Philip sat to watch the German Army perform the ceremony of beating the retreat in the castle's gardens, lighted with thousands of candles. It was a grand finale.

The key

Yet the key to this whole evening had been the banquet.

The menu: pâté, oxtail soup, chicken, strawberries. Wines: a 1959 Rhine wine, a 1961 Moselle, a 1961 Riesling, a rare French 1959, and German champagne.

Fairly simple fare. The speeches were much more complicated. *This is what the Queen said :*

● This visit will take me from the south to the northern plains of Germany and from the banks of the Rhine to Berlin, and I look forward to meeting people in all walks of life and in all parts of Germany.

I am also looking forward to seeing Hanover and other places of historic and personal interest.

The German and British people were very closely associated for many centuries. For most of their history they have been friends and often allies.

They have given each other much in civilisation and culture. Throughout the centuries there has been a constant traffic in music and painting. In all forms of cultural and intellectual

Turn to Page Six

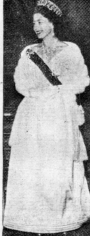

Radiant entrance by the Queen

GIRL ARTIST STABBED TO DEATH

Express Staff Reporter

THE night 19-year-old artist Julie Whittaker broke a promise to her father she died—stabbed in a lilac-shrouded lane five yards from her home.

The promise: that she would never walk down "Lilac Lane" alone at night.

She always waited at a friend's home for her father to meet her and escort her down "Lilac Lane," where several women have been attacked. But late on Monday night her killer met her instead.

Her screams were ignored, and red-haired Julie was left dying at her back gate in Gatley, Cheshire. She was found 15 minutes later by a 17-year-old youth.

A senior detective said last night : "This was a particularly brutal murder. There appears to be no motive. There was no struggle and she had not been assaulted."

Julie normally waited for her father at Jennifer Loftus's house 200 yards from her own home. But on Monday, after an evening out, she left Jennifer at 10.30—and started off home.

Now more than 100 police are trying to fill in the vital minutes after that.

POCKET CARTOON
by OSBERT LANCASTER

LADIES

"*Not a word to the Daily Express—but it looks very much as though some member of the Government has made rather a silly mistake.*"

Lady Churchill picks title

Lady Churchill, given a life peerage on May 1 has decided on her official title. She will be known as Baroness Spencer-Churchill, of Chartwell, in the County of Kent.

Paintings found

The two Turner landscape paintings missing from Harrow School turned up yesterday at Norbury, Middlesex, about five miles away. Two boys found them wrapped in newspaper on a canal towpath.

Canada bound

Earl Mountbatten left London for Canada yesterday on a fact-finding mission for the Commonwealth Commission on Immigration, which he heads.

Murder-charge man sees wife

William Brittle, charged with murdering recluse Peter Thomas, was yesterday visited by his wife, who had not seen him for three months.

The cell reunion took place below the dock of Gloucester Assizes where Brittle's trial is being held before Mr. Justice Phillimore. The trial—Page 11.

A-men walk out

Several departments at Harwell Atomic Research Establishment, Berkshire, closed down yesterday after 350 skilled men struck over a job dispute between the management and a shop steward.

Springtime snow ... fell in high parts of North-West Durham yesterday.

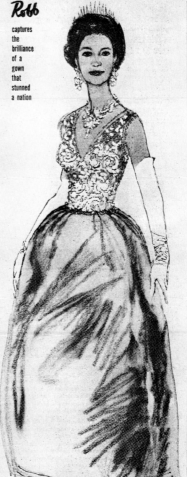

Robb captures the brilliance of a gown that stunned a nation

BEING beautifully dressed means being perfectly dressed for the occasion. The Queen is always just that. Last night, for her first evening reception, the Queen paid her German hosts the delicate compliment of wearing a gown in the blue and white of the family colours of the creator of Schloss Augustusburg. The dress is shaped like a hock glass, with narrow stem bodice and belling skirt. It glitters like a chandelier. The bodice, of turquoise blue organza is entirely encrusted with bead embroidery—tiny white china beads and lozenge and rose cut diamante. Mr. Hardy Amies, the London couturier, was inspired to this embroidery motif by the lavish rococo decorations by Cuvilliès at Schloss Augustusburg. The shining skirt gleams in pale turquoise blue satin with a tiered, stitched hemline.

Balenciaga, 1953

11 **Dark grey coat.** French. Balenciaga, no. 98, August 1960: of satin. It has a full pleated back, a deep square collar fastening with a faceted jet button and three-quarter kimono sleeves.
Worn and given by the Baroness Alain de Rothschild

12 **Suit.** French. Balenciaga, no. 99, August 1960: of black wool. The fitted *jacket* is trimmed at high round neck and hip with a black wool fringe. It has three-quarter-length kimono sleeves. The *skirt* is straight.
Worn and given by Princess Stanislaus Radziwill

13 **Black evening dress.** French. Balenciaga, no. 177, August 1960: of poult; strapless; the back of the skirt full and draped to a bow at the waist.
Worn and given by Mrs Loel Guinness

14 **Pink melanex evening outfit.** French. Balenciaga, no. 99, August 1961: the *tunic* is of melanex, chenille and crystal beads. It is knee-length, fitted and has a high round neck and elbow-length sleeves. The *trousers* (Yves St Laurent) are of matching wild silk.
Worn and given by the Baroness Philippe de Rothschild

15 **Pink melanex coat.** French. Balenciaga, no. 99, August 1961: it is completely embroidered in melanex, chenille and crystal beads. The coat is fitted and has a high round neck and elbow-length sleeves.
Worn and given by Mrs Loel Guinness

16 **Pink printed evening dress.** French. Balenciaga, no. 37, February 1961: of silk organza printed with carnation pinks: it has a low round neck and skirt bouffant at the hips. It is worn with a small matching triangular *scarf*.
Given by the Baroness Alain de Rothschild, who wore it at Versailles for the State visit of King Baudouin and Queen Fabiola in May 1961

17 **Cerise evening dress.** French. Balenciaga, no. 149, February 1961: of gazar. It is a strapless sheath, shorter in the front with deep flounces from hip to hem and a narrow train attached at the waist.
Worn by the late Mrs Stavros Niarchos and given by Mr Stavros Niarchos

18 **Floral embroidered short evening dress.** French. Balenciaga, 1962: a sleeveless sheath dress of white wild silk, hand-embroidered in Chinese style.
Worn and given by Viscountess Lambton

19 **Black lace and cream evening dress.** French. Balenciaga, no. 139, February 1962: it has a black lace top, frills framing the wide off-the-shoulder neckline and trimming the three-quarter-length sleeves. The full skirt is of cream silk gazar (Starron).
Worn and given by Mrs Ian Fleming

20 **Black sequin afternoon dress.** French. Balenciaga, 1962: of rachelle knit jersey: a sheath with a high round neck and elbow-length sleeves. Worn and given by Mrs Gilbert Miller

21 **Evening outfit.** French. Balenciaga, no. 32, August 1963: a gilt mesh rhinestone studded waist-length *jacket* worn over a strapless *dress* with a brown chiffon bodice and white silk gaberdine skirt. Worn and given by Mrs Loel Guinness

22 **White evening cape.** French. Balenciaga, no. 195, February 1963: double-breasted and made from gazar, bordered with a deep flounce. It was originally designed to be worn with a matching dress. Worn and given by Mrs Loel Guinness

23 **White evening coat.** French. Balenciaga, about 1965–66: made from silk gaberdine. It is full-length, flares from the shoulders, has a narrow band collar and three-quarter length kimono sleeves. Worn and given by Mrs Gilbert Miller

24 **White coat.** French. Balenciaga, no. 116, August 1966: of silk matelassé: three-quarter length and straight with lap-over front, notched collar and three-quarter length bat-wing sleeves Worn and given by Mrs Gilbert Miller

25 **Pink evening coat.** French. Balenciaga, about 1966: of matelassé, flared with a kimono sleeve, a band collar and horizontal pockets. Worn with matching, slightly pointed court *shoes* (René Mancini). Worn and given by Mrs Paul Mellon

26 **Shaded pink sequin evening outfit.** French. Balenciaga, no. 81, Summer 1967: entirely covered in sequin shapes. It is a three-quarter length *coat*, straight cut with an edge-to-edge closure fastening with a satin belt. The neck is round and the sleeves three-quarter length. It is worn with *trousers* of pink poult taffeta and *shoes* (Vivier) of transparent plastic trimmed with pink, chisel toes and low heels. Worn and given by the Baroness Philippe de Rothschild

27 **Evening outfit.** French. Balenciaga, nos. 69/72, 1967: of pure silk black zibeline (Starron). The *dress* high-necked and sleeveless flares from shoulders to the knee in front and sweeps to the ground at the back. It is cut with a single seam. The *cape*, is shorter and semi-circular with a similar asymmetric sweep. Worn and given by Mrs Loel Guinness

28 **Black dress.** French. Balenciaga, about 1967–68: of gazar (Starron): a sleeveless sheath with a flounce at the hem. Worn and given by Mrs Gilbert Miller

29 **Blue evening dress.** French. Balenciaga, about 1967–68: of pure silk gazar (Starron): it has a high round neck, cape sleeves, and the fullness sweeps smoothly from a yoke. Worn and given by Mrs Gilbert Miller

30 **Sea-green evening outfit.** French. Balenciaga, February 1968: the straight knee-length *tunic* of iridescent sequins has elbow-length sleeves and is worn with a straight *skirt* in matching organza. Worn and given by the Baroness Alain de Rothschild

31 **Royal blue dress and cape.** French. Balenciaga, about 1968: of royal blue gazar (Starron). It has a sleeveless fitted top and a flared skirt, which like the waist length matching *cape* is trimmed with a daisy braid. Worn and given by Mrs Paul Mellon

32 **Beige striped jacket.** French. Balenciaga, about 1968: of jersey with horizontal bands of pink and blue. It is hip length with slits at the back, a turned down collar and long sleeves. Worn and given by Mrs Paul Mellon

BALMAIN (France): Pierre Balmain

Born 1914 near Aix-les-Bains, worked with Captain Molyneux and Lucien Lelong before opening his own Salon at 44 rue François Premier in October 1945. His clothes have an exuberant femininity.

33 **Bridal jacket and headdress.** French. Balmain. 1945–46: made from white satin quilted and embroidered with pearls. It is fitted and waist length with long sleeves tapering at the wrist. The *headdress* (Paulette), a small matching pillbox cap. The *jacket* was originally worn with a skirt of white faille. Worn by Miss Stella Carcano at her marriage to Viscount Ednam, 10 January 1946, and given by her. 'This was the first society marriage for which I designed the bride's and bridesmaids' dresses' (P. Balmain, *My years and seasons*. Trans. E. Lanchbery, C. Young, 1964)

34 **Crimson evening dress.** French. Balmain, 1950 of velvet: the bodice has a single strap and is trimmed with sable. It is a sheath with a short fish-tail train. Worn and given by Stella Lady Ednam

35 **Yellow evening dress.** French. Balmain, 1956: of satin, the strapless bodice and bouffant skirt trimmed with a triangular central panel edged with looped bands. Worn and given by Lady Elizabeth von Hofmannsthal

36 **Rose-patterned evening dress.** French. Balmain, 1957: of cream warp printed silk. The strapless bodice has the waist trimmed with appliqué rose motifs which shade into the bouffant skirt.
Worn by Lady Diana Duff Cooper at the Ball given by the British Ambassador for the visit of H.M. The Queen and Prince Philip in March 1957, and given by her

37 **Black short evening dress.** French. Balmain, 1957: the fitted bodice has two straps and the very full skirt is made from layers of tightly pleated net.
Worn and given by Lady Elizabeth von Hofmannsthal

38 **Black short evening dress.** French. Possibly Balmain; 'Tuileries', about 1960: it has a strapless bodice and bouffant skirt of net with white felt spots, draped over layers of gauze and gathered black net frills, which form a bustle at the back.
Worn and given by Stella, Lady Ednam

BELINDA BELLVILLE (Bellville Couture) (England)

She started a London couture house in about 1956 and was later joined by David Sassoon as co-designer. The house is known for its young romantic evening dresses.

39 **Golden yellow evening dress.** English. Belinda Bellville, boutique collection 1968: of yellow wild silk with bodice of organdie embroidered with lattice pattern in gold, yellow and orange, three-quarter sleeves and roll-neck collar.
Worn and given by H.R.H. The Princess Anne

CALLOT SOEURS (France)

The four sisters opened a lace shop in 1888 and the eldest, Marie (Madame Gerber), developed the couture side at 24 rue Taitbout, and enlarged it at 9 avenue Matignon, where it continued until 1935. She is known for her use of lace and decorated sheer fabrics.

40 **Yellow evening dress.** French. Callot, about 1922: of voile printed with a floral pattern, re-embroidered with pearl sequins. A flounce of gold lace trims the slightly flared skirt. It is sleeveless. There is a sequin belt with paste buckle at the low waist.
Worn by Winifred Duchess of Portland and given by Lady Victoria Wemyss

Pierre Cardin, 1958

PIERRE CARDIN (France)

Born 1922 of French parents, settled in Venice, trained as an architect before starting his own boutique. He worked with Christian Dior 1946–52 and opened on his own at 118 Faubourg St Honoré. He is known for his clothes, which are avant garde, yet feminine.

41 **Space suit.** French. Pierre Cardin, 1967: a red jersey *tabard* with black vinyl circular motif worn over a black ribbed jersey polo-necked *sweater* and *tights,* worn with a black jersey *skull cap, sunvisor* and black plastic knee *boots.*
Given by Monsieur Pierre Cardin

BONNIE CASHIN (USA)

Began to make clothes in Hollywood in 1950. In 1953 she started her own establishment known for the ingenuity and variety of its sports clothes.

42 **Sweater and trousers.** USA. Bonnie Cashin Design, about 1959: the *trousers* are of black leather, the hip yoke fitted with straps and buckles; the *sweater* of white knitted cashmere with a polo neck and long sleeves. These trousers were first designed in 1955 and continued in production until about 1965.
Worn and given by the Countess of Avon

CASTILLO (France): Antonio Canovas del Castillo

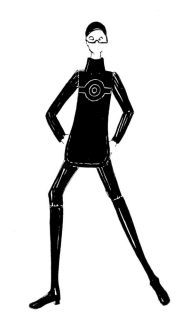

Came to Paris from Spain in 1936. He worked with
Robert Piguet, Paquin, Chanel and with Elizabeth Arden
in New York before joining Lanvin in 1950, leaving in
1963 to start his own house, which closed in 1969. His
clothes display a worldly elegance.

43 **Pale green evening coat.** French. Castillo, 1967:
of pure silk zibeline (Starron). It has a high round neck
and three-quarter length sleeves. The front and back are
panelled.
Worn and given by Madame Martinez de Hoz

44 **Pink feather evening coat.** French. Castillo,
1968: completely covered with ostrich fronds intermixed
with silver melanex strips. The coat has a high round neck
and elbow-length sleeves. It is un-waisted and straight
cut. It was designed to be worn with an embroidered pale
pink dress.
Worn and given by Mrs Loel Guiness

JOHN CAVANAGH (England)

Irish-born designer who worked with the Paris couturier
Edward Molyneux 1932–39, and Pierre Balmain 1945–51,
opening his own establishment in 1952. His clothes are
subtly cut and have a youthful quality.

45 **Wedding dress.** English. John Cavanagh, 1961:
made from gossamer white silk gauze woven with a
formal design in iridescent silvery thread (Petillault). The
dress has a fitted bodice and a roll collar standing away
from the neck and tight sleeves. The fifteen-foot train
banded in white satin is double and matched in length by
the silk tulle veil held in place by a diamond bandeau.
The original headdress was designed by Reed Crawford.
Worn by Miss Katherine Worsley at her marriage to
H.R.H. The Duke of Kent at York Minster, 8 June 1961
Given by the Duchess of Kent

46 **White cocktail suit.** English. John Cavanagh,
Autumn 1963: a high-necked, semi-fitted *jacket* with its
three-quarter length sleeves and slightly flaring *skirt* is
of pure silk zibeline (Starron). It was originally worn with
a sleeveless overbodice of brown organdie embroidered
in bronze and gold. The model as originally designed had,
not a short jacket, but a topcoat of white silk with a
sable collar.
Worn and given by the Hon. Mrs J. J. Astor

Space suit by Pierre Cardin, 1967. Cat. 41. Courtesy of
Pierre Cardin

Chanel, 1953

50 **Black sequin evening suit.** French. Chanel, 1937–38: the bolero *jacket* and loose, straight *trousers* are entirely covered with sequins. *En suite* is a *blouse* of cream chiffon with soft turned-down collar and jabot trimmed with lace.
Originally worn with a black ribbon round the neck into which was tucked a red rose.
Worn and given by Mrs Diana Vreeland

51 **Scarlet suit.** French. Chanel, no. 4, March 1960: of wool; the semi-fitted *jacket* has a tailored collar and button trimmed pockets at bust and hips.
Worn by the late Mrs Stavros Niarchos and given by Mr Stavros Niarchos

52 **Lilac suit.** French. Chanel, no. 11, Spring 1964: the semi-fitted *jacket* of wool is lined with lilac floral printed organza which faces the small step lapels, the breast and hip pockets and is used for the *bodice* attached to the suit skirt.
Worn and given by the Baroness Alain de Rothschild

CHANEL (France): Gabrielle Chanel

Began as a milliner before 1914, and opened her couture house in 1919, in 31 avenue Matignon. She became known for her simply styled supple clothes, many in jersey fabrics, and for her ubiquitous simple workmanlike Chanel suit. She closed in 1939 and re-opened in 1954.

47 **Black beaded evening dress.** French. Chanel, 1919: a straight sleeveless tunic with embroidered bands in a grape design.
The petticoat is a modern replacement.
Worn by the Hon. Mrs Anthony Henley at celebrations associated with the Peace Conference 1919, and given by her

48 **Black beaded evening dress.** French. Chanel, about 1922: a sleeveless dress of georgette, the low waisted bodice embroidered with curved bead motifs and the slightly flaring skirt with embroidered bands. Black silk drapes trim the sides of the skirt.
Worn and given by the Hon. Mrs Anthony Henley

49 **Black sequin evening outfit.** French. Chanel, 1936–37: with scarlet satin drapes knotted across the bodice and down the flaring skirt. The short matching semi-circular *cape* is lined with scarlet satin.
Worn and given by Mrs Leo D'Erlanger

MARCELLE CHAUMONT (France)

Worked with Madeleine Vionnet and opened her own house, probably in the 1940s. Closed 1952.

53 **Pink and blue evening dress.** French. Marcelle Chaumont, 'Arc en Ciel', about 1950: of shaded organza. Draped bodice with long attached stole and full flared skirt.
Worn and given by the Countess Chauvignac

54 **White and gold evening dress.** French. Marcelle Chaumont, about 1955: a tucked strapless bodice and a circular skirt of organdie painted with a gold design of bows and ribbons.
Worn and given by Mrs Loel Guinness

SYBIL CONNOLLY (Ireland)

Irish couturier trained at Bradleys in London. She opened a shop in Grafton Street in 1950 and her present establishment, 71 Marion Square, in 1957. She is known for her use of Irish fabrics and graceful informal styling.

55 **Evening dress.** Irish. Sybil Connolly, 'Apple blossom' 1966: the long full *skirt* of pale green horizontally pleated Irish linen, the *blouse* of white Irish cambric hand-embroidered with blossom and a pink satin *belt*.
Given by Miss Sybil Connolly

COURRÈGES (France) : André Courrèges

Born at Pau, trained and worked with Balenciaga 1950–61, when he opened his own establishment at 48 avenue Kléber, moving to 40 rue François Premier in 1966, where he is known for his finely tailored, under-stated futuristic clothes. His 'couture future' collections, ready to wear and made in his own workrooms, were introduced in 1966.

56 **White dress and jacket.** French. Courrèges, no. 43, Autumn/Winter 1963: the straight cut high-necked sleeveless *dress* and loose waist-length *jacket* are of heavy horizontally ribbed cotton.
Worn and given by Princess Stanislaus Radziwill

57 **Pale pink short evening dress and jacket.** French. Courrèges, no. 22, Winter 1964: entirely embroidered in sequins: the *dress* is sleeveless and has a square neck and the skirt gathered slightly on to its low waist: the *jacket*, loose and waist-length, has narrow revers.
Ref: L'Officiel, September 1964, p. 146.
Worn and given by Princess Stanislaus Radziwill

58 **Red day dress.** French. Courrèges, no. 27, Spring 1966 (Couture future collection): of wool gaberdine. The dress, a flaring tunic, has a square-necked yoke, is sleeveless and has horizontal pockets at the hips.
Worn by the late Mrs Stavros Niarchos and given by Mr Stavros Niarchos

59 **White dress.** French. Courrèges, no. 54, Spring 1967: a short flaring shift with a high square neck, sleeveless, of cotton duveteen arranged in wide bands alternating with panels of daisy openwork embroidered organza.
Worn and given by Princess Stanislaus Radziwill

60 **Beige coat.** French. Courrèges, no. 87, Winter 1967: single-breasted and made from wool with a curving yoke, small turned-down collar and large semi-circular side panels in white.
Worn and given by Mrs Loel Guinness

61 **Brown and white coat.** French. Courrèges, no. 88, Winter 1967: double-breasted and made from white gaberdine, the small high collar, bracelet-length sleeves and side skirt panels in brown and white stripes.
Ref: L'Officiel, October 1967, p. 15.
Worn by the late Mrs Stavros Niarchos and given by Mr Stavros Niarchos

62 **Almond green day dress.** French. Courrèges, no. 49, 1967 (Couture future collection): of gaberdine. The short straight dress has a yoke with square neck, short straight sleeves and a low waist with belt and with two semi-circular pockets.
Worn by the late Mrs Stavros Niarchos and given by Mr Stavros Niarchos

Courrèges, 1968

JEAN DESSÈS (France)

Of Greek parentage, began to design clothes in 1925 and in 1937 opened his own house in Paris, which lasted into the mid-1960s. He died in 1970. He is known for his evening dresses made of softly draped sheer fabrics

63 **White evening dress.** French. Jean Dessès, 1948: of chiffon with a loosely draped bodice and the hem arranged in gathered swags.
Worn and given by Ava, Viscountess Waverley

64 **Black evening dress.** French. Jean Dessès, probably 1948: of velvet with a small woven check pattern. The fitted bodice has a wide round neck with black velvet facing, and has small cap sleeves: the skirt is arranged to drape in panniers knotting at the back.
Worn and given by the Hon. Mrs J. J. Astor

65 **Beige evening outfit.** French. Jean Dessès, 1950: made from silk net: the tightly fitted strapless *dress* is arranged in diagonal pleats with a wide flounce from knee to hem and a *cape* of gathered net.
Worn and given by the Hon. Mrs J. J. Astor

CHRISTIAN DIOR (France)

Born Granville 1905, worked with Robert Piguet and Lucien Lelong and leapt to fame with his 'New Look' collection of Spring 1947. His house, 30 avenue Montaigne, retained its reputation through the fifties. He created the H-line in 1954 and the Y-line in 1955. He died in 1957, and Yves St Laurent and subsequently Marc Bohan, have carried on and developed the reputation of the House of Dior, known for its luxurious and finely made clothes.

66 **Green and white day dress.** French. Christian Dior, 'Miss New York' 1947: made from spotted foulard. The bodice has a tailored collar, long bat-wing sleeves and a tightly fitted waist: the skirt is straight with gauged front fullness and a triangular handkerchief drape behind. *Ref: British Vogue*, April 1947, p. 49. Illustration: 'Kerchief back drapery'.
Worn and given by Mrs Joseph Alsop

67 **Black dress.** French. Christian Dior. 'Maxime', 1947: of black broadcloth. It has a plunge neckline filled with a black velvet bow and three-quarter length bat-wing sleeves. The waist-band is fitted and the flared skirt pleated at the centre back. Worn with a single strand paste *choker*.
Dior's first collection: the 'New Look'.
Ref: British Vogue, April 1947, p. 46; sketch by Lila de Nobilis: 'Dior . . . the new name in Paris . . . his ideas were fresh and put over with great authority . . . Take the dress opposite for example . . . in black broadcloth (one of Dior's favourite fabrics) a wide waist-band whittling the waist, a deep widely cut bodice formed from a black velvet bow; the whole compact of elegance from the shirred net hat, large as a lampshade, to the pointed Spanish pumps.'
Worn and given by Mrs David Bruce

68 **Black evening dress.** French. Christian Dior, 1950: of satin. The bodice is strapless and the full flared skirt trimmed at the side with a large bow of black velvet.
Worn and given by Baroness Antoinette de Ginsbourg

69 **Blue embroidered short evening dress.** French. Christian Dior, 'Bosphore', Autumn/Winter 1956: a strapless bell-skirted sheath of velvet, with a formal floral design in gold thread and brilliants.
Worn by the late Mrs Stavros Niarchos and given by Mr Stavros Niarchos

70 **Cream embroidered evening dress.** French. Christian Dior (Monsieur Dior's Collection), about 1956: of wild silk with gold and brilliants in a floral design. It has a low round neck and sleeveless fitted bodice and a slightly gathered skirt.
Worn and given by Mrs Gilbert Miller

Day dress by Courrèges, 1967. Cat. 62. Courtesy of Courrèges, 1968

71 **White spotted tulle evening dress.** French.
Christian Dior, Spring/Summer 1957: with a draped fichu,
and a gathered bouffant skirt.
Worn at the dinner given for Her Majesty the Queen and
Prince Philip at the British Embassy in Paris, March 1957,
and given by the Baroness Alain de Rothschild

72 **'Eau de nil' short evening dress.** French. Christian
Dior, Spring/Summer 1957: of organza with a draped
fichu collar trimmed with a self-coloured rose centre front
and a bouffant pleated skirt.
Worn and given by the Baroness Antoinette de Ginsbourg

73 **Coffee lace evening dress.** French.
Christian Dior, Spring/Summer 1958: with loosely fitting
tunic top, trimmed centre front with a matching silk bow,
round neck and elbow-length sleeves and a straight skirt.
Worn and given by Madame de Callejon Propper

74 **Black beaded short evening dress.** French.
Christian Dior, Spring/Summer 1959: of net with low
round neck, elbow-length sleeves and with the net draped
over the bell-shaped skirt and caught up at intervals with
black satin bows.
Worn and given by the Duchess of Windsor

75 **Coral embroidered evening dress.** French.
Christian Dior, Spring/Summer 1960: the bodice is
heavily embroidered with real and paste coral, diamanté
and metal thread arranged in a formal pattern: it has a
high round neck, three-quarter sleeves and a slightly
gathered zibeline skirt.
Worn and given by Mrs Walther Moreira Salles

76 **Grey beaded evening outfit.** French. Christian
Dior. 'Estoril', Autumn/Winter 1960: *tunic* of nylon net
(Dognin), embroidered in silver thread, brilliants and silver
thread tassels (Rebé), is flared and semi-fitted with a
low, wide neckline and elbow-length sleeves. Worn with
pale pink wild silk *trousers*.
Ref: L'Officiel, September 1960, p. 141. Where tunic is
shown as originally designed with a skirt.
Worn and given by the Baroness Philippe de Rothschild

77 **Black sequin short evening dress and jacket.**
French. Christian Dior, 'Maxim's', Autumn/Winter 1961–
62: a straight dress, sleeveless with a high round neck,
the bodice of black velvet and the slightly flared skirt of
black sequins with an all-over interwoven design to
match the loose hip-length *jacket* which has a small tail-
ored collar and bracelet-length sleeves.
Worn and given by Mrs Loel Guinness

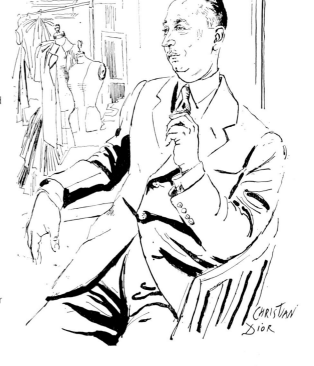

Christian Dior, 1953

78 **Pink evening dress.** French. Christian Dior, Spring/Summer 1962: it is made from silk organza, with an embroidered design in pink and silver thread and appliqué of long-stemmed rosebuds. It is a strapless, high-waisted sheath.
Ref: L'Officiel, June 1962, p. 89.
Worn by the late Mrs Stavros Niarchos and given by Mr Stavros Niarchos

79 **Grey embroidered evening dress.** French. Christian Dior, designed by Marc Bohan in Spring/Summer 1962: it has shoulder straps and is a high-waisted sheath of silver net with motifs in silver sequins and brilliants.
Worn and given by Mrs Loel Guinness

80 **Yellow embroidered evening outfit.** French. Christian Dior, Spring/Summer 1964: made from silk organza with horizontal bands of alternating bead and ribbon embroidery. The dress is strapless with a straight skirt. It is worn with a small matching *bolero* jacket.
A special design for Mrs Loel Guinness, by whom it was given

81 **Pale-green printed dress.** French. Christian Dior, 1965: in water-lily patterned chiffon: a draped, long-sleeved tunic.
Worn and given by Lady Abdy

82 **White evening coat.** French. Christian Dior, Autumn/Winter 1966: of wool. It is double-breasted and flared with a turned-down collar and bracelet-length sleeves. It has white domed buttons studded with brilliants.
Worn by the late Mrs Stavros Niarchos and given by Mr Stavros Niarchos

83 **Striped evening dress.** French. Christian Dior, Spring/Summer 1967: a strapless sheath in striped chiffon covered with a single-sleeved flowing mantle in matching material with a bead and sequin collar and cuff.
Ref: L'Officiel, March 1967, p. 125.
Worn by the late Mrs Stavros Niarchos and given by Mr Stavros Niarchos

84 **Black feather trim evening dress.** French. Christian Dior, Spring/Summer 1967: of silk chiffon with bands of black ostrich feathers. It has a high round neck and long wide sleeves.
Worn and given by Mrs Walther Moreira Salles

85 **Melanex embroidered evening dress.** French. Christian Dior, Spring/Summer 1968: a high waisted slightly flared sheath with a high round neck and short sleeves entirely embroidered with a palmette pattern in pastes and melanex appliqué.
The dress was based on no. 115 in the Spring/Summer Collection 1968 but the embroidered pattern was designed exclusively for this dress.
Worn by the late Mrs Stavros Niarchos and given by Mr Stavros Niarchos

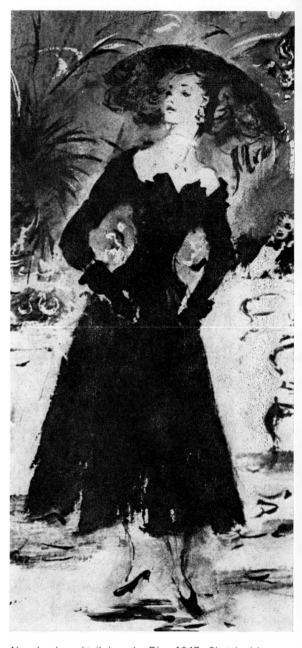

New Look cocktail dress by Dior, 1947. Sketched by Lila de Nobilis. Cat. 67. Photo copyright Condé Nast Publications Ltd

86 **Black evening outfit.** French. Christian Dior,
1968: a strapless sheath of tiers of chiffon worn with a
flowing matching *coat* with long wide sleeves.
Worn and given by Viscountess Lambton

87 **Green tweed trouser suit.** French. Miss Dior.
Probably 1968: of herringbone tweed: the jacket is hip-
length and single-breasted with a turned-down collar and
a belt: there is a button flap on the left shoulder: the
trousers are straight cut.
Worn by the late Mrs Stavros Niarchos and given by Mr
Stavros Niarchos

88 **Pink day outfit.** French. Christian Dior, no. 33,
Spring/Summer 1969: the dress of pink 'crepe drapé'
(Bianchini), with a v-neck, double-breasted fastening,
shirt sleeves and flat pleated skirt; the *jacket* is of pink
grosgrain, hip-length and slightly shaped with pockets: a
long fringed *scarf en suite*.
Though closely based on no. 32, Spring/Summer 1969, it
differs in not having a breast pocket and welted front.
Worn by the late Mrs Stavros Niarchos and given by Mr
Stavros Niarchos

89 **Blue printed day dress.** French. Christian Dior,
no. 16, Spring/Summer 1969: in a patchwork design. It
has a scarf tied at the neck, long shirt sleeves and the
skirt is pleated.
Worn and given by Madame Martinez de Hoz

90 **Red and gold oriental printed dress.** French.
Marc Bohan at Christian Dior, 1969: with long sleeves
and v-neck, high-waisted with matching ostrich frond
trimmed girdle.
Worn and given by Lady Abdy.

MARY DONAN (England)

An English couture dressmaking establishment, which
makes exclusive models for a large private clientele. It was
founded in 1930, closed 1939 and re-opened in 1947.

91 **Yellow evening dress.** English. Mary Donan,
1969: of georgette: a sheath with bodice draping from
single strap and a flowing train from the shoulders.
Worn and given by Her Royal Highness Princess
Alexandra

ADELE AIAZZ1 FANTECHI (Italy)

Florentine dressmaking establishment, established as a
milliner's 1885 and since 1930 engaged in copying
French models.

92 **Floral beaded short evening dress.** Italian.
Adele Aiazzi Fantechi, 1959: made from blue and yellow
silk printed with floral design and entirely covered with
bead fringe. It is a shift with a high round neck and
sleeveless. Worn with matching *shoes*, sling-backed, with
pointed toe, platform sole and stiletto heel.
Worn and given by Madame Traballesi

93 **Pink net evening dress.** Italian. Adele Aiazzi
Fantechi, 1963: with peaked graduated bands of sequined
embroidery. It is a flaring shift, sleeveless, with a round
neck.
Worn and given by Madame Traballesi

94 **Grey printed day dress.** Italian. Adele Aiazzi
Fantechi, 1966: of foliage-patterned chiffon. It has pleats
falling from a yoke, high round neck and long sleeves.
Worn and given by Madame Traballesi

JACQUES FATH (France)

Born 1912 and began designing in 1937–8. In 1944 he
moved to 39 avenue Pierre Premier de Servie, where he
became known for his luxurious feminine designs. He
committed suicide in 1954 but his house was carried on
until 1957 by his widow Genevieve.

95 **Lilac lace evening dress.** French. Jacques Fath,
1957: with a plain sleeveless low-neck bodice and a
double tier bouffant skirt and a matching velvet sash.
Worn by Lady Gladwyn at the Ball to celebrate the visit
of H. M. Queen Elizabeth and Prince Philip to Paris,
March 1957 and given by her

FORTUNY (Italy): Mariano Fortuny y de Madrazo

Born 1871, was a Spanish designer who lived and worked in Venice until his death in 1949. Many of his textiles are created in the Renaissance idiom and his styles based on classical Greek forms.

96 Apricot pleated evening dress. Italian. Fortuny, about 1912: it is made from silk and is Doric Chiton in shape.
Given by Miss Irene Worth

MR FREEDOM (England)

Founded by Tommy Roberts in 1969, moving from King's Road to Kensington Church Street in 1970: his clothes have a bright 'pop-art' impact.

97 Star-patterned 'T' shirt. English. Mr Freedom, September 1969: of red cotton with black star pattern. It has a low neck and long sleeves.
Given by Mr Freedom

98 Mickey Mouse 'T' shirt. English. Mr Freedom, September 1969: of yellow cotton jersey with low neck and long sleeves and scarlet Mickey Mouse heads applied to the front.
Given by Mr Freedom

99 Pop art tie. English. Mr Freedom, September 1969: in blue and green crepe with Andy Warhol type amorous 'movie' couple design.
Given by Mr Freedom

100 Rock and roll skirt. English. Mr Freedom, November 1969: circular and flared with braid banded border trimmed with appliqué music and 'rock and roll' design.
Given by Mr Freedom

101 Yellow satin cowboy shirt. English. Mr Freedom, December 1969: with press-button fastening and blue star appliqué on collar.
Given by Mr Freedom

102 Donald Duck 'T' shirt. English. Mr Freedom, December 1969: of yellow wool jersey with high round neck, red long sleeves set in the shoulders and Donald Duck appliqué on centre front.
Given by Mr Freedom

103 Star-patterned 'T' shirt. English. Mr Freedom, March 1970: of blue and white star-patterned jersey, trimmed with red and white star pattern patch appliqué.
Given by Mr Freedom

104 Cravat sweater. English. Mr Freedom, September 1970: of white jersey with red and orange cravat design on the front.
Given by Mr Freedom

105 Scarlet football sweater. English. Mr Freedom, September 1970: with '15' motif knitted into the front.
Given by Mr Freedom

106 White and scarlet baseball suit. English. Mr Freedom, September 1970: of white cotton duck with scarlet patch appliqué. The *jacket* is waist-length with centre front-lace fastening and the *knicker-bockers* are bound with scarlet at the waist and have oval designs at the knees.
Given by Mr Freedom

107 Yellow 'Desperate Dan' boots. English. Mr Freedom, October 1970: ankle boots with blue toe-caps and winged appliqué at the ankle.
Given by Mr Freedom

108 'Woolworths' 'T' shirt. English. Mr Freedom, October 1970: of yellow wool jersey with long green sleeves set into the shoulders, where they are bound with black like the high round neck. Flock printed across the front 'God Bless Woolworths'.
Given by Mr Freedom

109 Pop art 'T' shirt. English. Mr Freedom, November 1970: of black cotton with low round neck and long sleeves with flock printed on the front 'PK Off' hearts and a couple embracing.
Given by Mr Freedom

110 'Bingo' jacket. English. Mr Freedom, November 1970: of black 'wetlook' vinyl, the front and sleeves trimmed with felt appliqué Bingo numbers.
Given by Mr Freedom

111 Jockey jacket. English. Mr Freedom, December 1970: of yellow and scarlet spotted nylon satin. It is waist-length with elasticated neck, cuffs and welt and centre front zip. The full sleeves and diagonal pockets are bound in red and white spotted cotton.
Given by Mr Freedom

112 Jockey cap. English. Mr Freedom, December 1970: in multi-coloured nylon satin.
Given by Mr Freedom

113 'Hamburger' shirt. English. Mr Freedom, January 1971: of printed satin with appliqué pocket.
Given by Mr Freedom

114 'Palm Springs' shirt. English. Mr Freedom, January 1971: of blue nylon with palm and lagoon 'Palm Springs' print. It has turned-down collar and pocket flaps in the yoke.
Given by Mr Freedom

115 Red checked gingham bow-tie. English. Mr Freedom, March 1971.
Given by Mr Freedom

116 Gingham trouser suit. English. Mr Freedom, March 1971: of green and white check cotton trimmed with braid '100 % cotton'. The *jacket* is hip length and fitted with wide pointed lapels in a small check also used for the *waistcoat*. The *trousers* are straight with turn-ups.
Given by Mr Freedom

117 Scarlet sailor suit. English. Mr Freedom, April 1971: of scarlet nylon satin: the *jacket* is semi-fitted with sailor collar trimmed with blue bands and fastens with a centre front zip. The *trousers* are long and similarly banded at the flared bottoms.
Given by Mr Freedom

118 'University of Wishful Thinking' vest. English. Mr Freedom, April 1971: sleeveless green stretch plush bound with pink: flock printed on the front 'University of Wishful Thinking'.
Given by Mr Freedom

119 Red shirt. English. Mr Freedom, May 1971: of red cotton with white yoke and sleeves and red collar and cuff bands.
Given by Mr Freedom

120 'Ramalama Ding Dong' 'T' shirt. English. Mr Freedom, June 1971: of green cotton with low round neck and long sleeves with black patch insertions and flock printed 'Ramalama Ding Dong' and musical stave.
Given by Mr Freedom

121 Artists 'smock'. English. Mr Freedom, July 1971: in multi-coloured random brush mark pattern cotton. It has a black satin tie at the neck and the brush and pallette appliqué at the hip.
Given by Mr Freedom

GALANOS (USA): James Galanos

An American of Greek parentage, works in California. He trained in New York and Paris with Robert Piguet. He founded his own dress house in 1954, and the clothes he designs are made up in his own factory. He is known for his successful use of dark colours and beautiful fabrics.

122 Crimson and black evening dress. USA. Galanos, Autumn 1959: it has a high waisted crimson velvet strapless bodice embroidered with black jet, braid, and chenille in formal floral pattern and a skirt of gathered black chiffon (Bianchini Ferrier).
Worn and given by Miss Eleanor Lambert

PRINCESS GALITZINE (Italy)

Russian born: she studied art and couture in Rome, opening her own establishment in 1959 and in 1960 introduced her 'Palazzo pyjamas'. She is known for her colourful and luxurious styling.

123 Floral silk palazzo pyjamas. English. Princess Galitzine, about 1962: a *jacket* of oriental pattern floral silk, of pinks and greens entirely beaded to pattern and trimmed with a silk bow. It is short-waisted with a low, wide round neck and three-quarter length kimono sleeves. Worn with tapering green silk *trousers,* a long openfronted flowered silk *skirt* and matching beaded *shoes.*
Given by Princess Galitzine

124 Pink palazzo pyjamas. Italian. Princess Galitzine, about 1963: the *top* is beaded and the *trousers* of pink silk trimmed at the side with gold braid.
Given by Princess Galitzine

BILL GIBB (England)

Trained at St Martin's College of Art, started on his own in 1968, and in 1969 joined 'Baccarat'.

125 'Renaissance' evening dress. English. Bill Gibb, 1970: in panels of silk brocade furnishing fabrics in shades of pink and blue trimmed with braid and tasselled streamers. It consists of a hip-length *jacket* with elbow puffed sleeves and gathered peplum worn with a long gathered *skirt.*
Worn by 'Twiggy' at the Daily Mirror Fashion Celebrity Dinner, 22 October 1970, and given by her

Givenchy, 1958

GIVENCHY (France): Hubert de Givenchy

Born in Beauvais, worked with Jacques Fath, Robert Piguet and Schiaparelli before opening his own salon near the Parc Monceau in 1951. In 1956 he moved to 3 avenue George V. His clothes have a refined distinction in the tradition of his master Balenciaga.

126 **Feather trimmed evening dress.** French. Givenchy, no. 3191, Autumn/Winter 1960: a trained fitted low necked and sleeveless sheath of black spotted net, mounted on blue taffeta and entirely covered with cock's feathers, braid and iridescent beads.
Worn and given by Mrs Loel Guinness

127 **Vermilion trouser suit.** French. Givenchy, probably early 1960s: of slubbed linen. The *tunic* is hip length and semi-fitted with short sleeves and a small roll collar. The *trousers* are straight.
Worn and given by Mrs Paul Mellon

128 **Black velvet coat.** French. Givenchy, 1964: flared with round neck and three-quarter kimono sleeves.
Worn and given by Mrs Gilbert Miller

129 **Coral embroidered evening dress.** French. Givenchy, no. 713, 10 February 1964: fitted with a high neck and sleeveless. It is of coral coloured lace re-embroidered with matching beads and raffia, with matching shoes.
Worn and given by Mrs Pierre Schlumberger

130 **Yellow suede evening coat.** French. Givenchy, no. 865, 11 August 1964: high-waisted with magyar sleeves and standaway neckline. The edges are trimmed with shell pattern gilt sequins.
Worn and given by Mrs Pierre Schlumberger

131 **Purple gazar evening outfit.** French. Givenchy, no. 503, 10 August 1966: fitted and sleeveless with a low back and covered with a full length flaring *cape:* the edges are trimmed with sequin strip and silver embroidery.
Worn and given by Mrs Pierre Schlumberger

132 **Black plastic embroidered evening coat.** French. Givenchy, no. 436, 10 August 1966: a short tent coat cut with a standaway band collar and elbow-length raglan sleeves. It is entirely embroidered in black melanex. chenille and jet.
Worn and given by Mrs Pierre Schlumberger

132a **White crepe evening dress with floral sequined bodice.** French. Givenchy, no. 109, Spring 1968: sleeveless with a v-neck at the front and a white silk ribbon tie and a low square-necked back, with a natural waistline.
Worn and given by Miss Audrey Hepburn

133 **Black feather-trimmed short** evening outfit. French. Givenchy, no. 201, 6 August 1968: a short-waisted sleeveless black velvet *overbodice* trimmed with feathers, is worn over a black silk *bodice,* to which is attached a *skirt* entirely covered with black curling peacock feathers.
Worn and given by Mrs Pierre Schlumberger.

134 **Printed evening outfit.** French. Givenchy, probably Summer 1969: *blouse* of grey organza with cow neckline and full gathered sleeves, worn with a flared *skirt* in linen printed in a floral pattern in yellow and blue. *En suite* are matching square-toed *court shoes* (René Mancini).
Worn and given by Mrs Paul Mellon

135 **Cream evening dress.** French. Givenchy, no. 530, 6 August 1969: of crepe. It is asymmetrically cut to leave one shoulder bare and is knee length at the left side, the pointed skirt reaching to the ankle on the right, with matching shoes (Vivier).
Worn and given by Mrs Pierre Schlumberger

136 **Black coat.** French. Givenchy, Winter 1969: of wool velour. It is single-breasted, belted, and flared with a small turned down collar set slightly away from the neck and kimono sleeves.
Worn and given by Mrs Paul Mellon

137 **Navy blue and white day dress.** French. Givenchy, Spring 1970: of linen with a high-necked raglan sleeved bodice. The slightly gathered skirt is horizontally banded in white.
Worn and given by Mrs Paul Mellon

138 **Printed day dress.** French. Givenchy, Summer 1970: of blue, brown and white diamond patterned cotton. It has a high round neck with wide elbow-length sleeves, a fitted bodice and slightly gathered skirt with a navy ciré tie belt.
Worn and given by Mrs Paul Mellon

139 **Purple iridescent sequin evening outfit.** French. Givenchy, 29 July 1970: a full length dress with bracelet length sleeves and slightly gathered skirt, trimmed at high neck and wrists with frills of purple organza, there is an organza open-fronted *overskirt* with a frilled edge and a sash.
Worn and given by Mrs Pierre Schlumberger

140 **Navy printed evening dress.** French. Givenchy, no. 773, Winter 1970: of silk faille with multi-coloured patch pattern. It has a fitted bodice with a low neck and long sleeves. There is a frill around the neck and above the hem.
Worn and given by Mrs Pierre Schlumberger

141 **Emerald green dress.** French. Givenchy, Winter 1970: of satin striped crepe it has a high round neck, kimono sleeves with buttoned wristband, skirt gathered on to a slightly low waist and matching tie belt.
Worn and given by Mrs Paul Mellon

142 **Royal blue satin evening dress.** French. Givenchy, Winter 1970: with a frilled collar at the high neckline, kimono sleeves and skirt gathered on to a slightly low waist with a tie belt.
Worn and given by Mrs Paul Mellon

143 **Vermilion evening outfit.** French. Givenchy, 1970: of taffeta with a small orange spot. The *dress* has a fitted bodice, long sleeves and a slightly flared skirt with frilled hemline. It is worn with a sleeveless knee-length *jacket* with a frilled border.
Worn and given by Mrs Paul Mellon

144 **Purple printed day dress.** French. Givenchy, 1970: of purple and white mottled silk. It has a high round neck and long sleeves and is slightly flared with a pleated frill at the hem. It has a navy blue satin belt and is worn with matching square-toed flat-heeled ankle strap *shoes* (René Mancini).
Worn and given by Mrs Paul Mellon

Grès, 1971

GRÈS/ALIX (France): Madame Grès

Trained as a sculptress and turning to haute couture, became 'Alix' in the Faubourg St Honoré. She re-opened at 1 rue de La Paix in 1941 as Grès. She is known for her skill in the subtle use of jersey and draping materials.

145 **Gold and black evening jacket.** French. Alix (Grès), 1938: a close fitting hip-length jacket of jacquard matelassé with a high square neck, and pleats at shoulders and cuffs of elbow length sleeves.
Worn and given by an anonymous lady

146 **Black spotted net dress.** French. Grès, about 1955: with high neck, long sleeves and gathered skirt with side drape.
Worn and given by Mrs Leo D'Erlanger

147 **Day outfit.** French. Grès, no. 144, Autumn 1966: of camel and pink double-faced wool (Labbé). The hooded slightly flaring *coat* is of camel with the fabric reversed to pink for the double-breasted front panel and the square hood. The *tunic* is pink, knee-length, slightly flaring with a high round neck and short sleeves, and the straight *skirt* is camel.
Worn and given by Princess Stanislaus Radziwill

148 **White evening dress.** French. Grès, 1968: of fine pleated silk jersey (Guillemin), with a single shoulder strap, swathed bodice and finely pleated skirt.
Worn and given by Princess Stanislaus Radziwill

149 **Printed evening dress.** French. Grès, no. 177, 1969: of white silk with a large geometric pattern in blue and black (Bucol). The cut is based on a rectangle with an opening for neck and arm. In wear it forms a dress leaving bare one shoulder and sweeping in a sideways asymmetric drape.
Worn and given by Mrs Graham Mattison

NICOLE GROULT (France)

A sister of Paul Poiret, though working completely independently. She opened her establishment in 1910 in 29 rue d'Anjou, and closed about 1932–33. She worked with the avant garde designers of the day, and showed regularly in England.

150 **Grey printed evening dress.** French. Nicole Groult, about 1932: of silk faille with warp printed hydrangea motif: it has a heart-shaped neckline and elbow-length sleeves and is a belted sheath with bouffant drapes from knee to ground with a bow in the centre front.
Worn and given by an anonymous lady

151 **Printed evening dress.** French. Nicole Groult, 1932: of taffeta with flowers printed on alternating grounds of grey and pink designed by Marie Laurencin (1885–1956, French painter and designer). It has a tight bodice and a full skirt. The neck is framed by a wide pleated band.
Worn and given by Ava, Viscountess Waverley

152 **Black and white day outfit.** French. Nicole Groult, about 1932: the short bolero *jacket* and flared *skirt* are made from black and white woven stripe maroccain. Orange crepe is used for the loose sleeveless *overblouse*. Jacket facing and the central panel of the skirt partially hidden when it is buttoned. A rose motif is embroidered on the right facing of the jacket and the left front of the blouse. Worn with black taffeta *mittens*.
Worn and given by an anonymous lady

NORMAN HARTNELL (England)

Opened his establishment in 1924. The longest established contemporary English couture dressmaker, he holds Royal warrants for Her Majesty the Queen Mother and Her Majesty the Queen. His Bruton Street salon is known for its formal dresses, which have a timeless quality, and its magnificent embroideries.

153 **White presentation dress.** English. Norman Hartnell, 1928: made from white silk tulle spangled with diamond shaped sequin motif. It has a tight bodice and the full skirt longer at the back is arranged in pointed flounces.
Worn at her Presentation at Court, 1928, by Lady Smiley and given by her

154 **Ivory satin State evening dress.** English. Norman Hartnell, 1957: it is low-cut with a wide flaring skirt, which has a bow at the back. It is encrusted with pearls, beads, brilliants and gold in a design 'flowers of the field of France' and the bees of Napoleon.
Worn by Her Majesty the Queen at the State visit to Paris, April 1957, for the Banquet at the Elysée Palace followed by the Opera, and given by her

155 **White State evening dress.** English. Norman Hartnell, 1959: of satin trimmed with aquamarine and turquoise embroidery in a frost flower design: it has a fichu collar around a low neck and decorative panels trimmed with pleated net on the full crinoline skirt.
Worn and given by Her Majesty the Queen Mother

JACQUES HEIM (France)

Began to extend his parents' establishment which specialized in furs, into a couture house in 1920. He moved to 15 avenue Matignon in 1935, started 'Heim Jeunes Filles' in 1936 and closed in 1969.

156 **Fuchsia evening dress.** French. Jacques Heim Jeunes Filles, 1959: of silk organza. There is a low-necked cap sleeved fitted bodice and the full bouffant skirt is arranged in envelope pleats at the back.
Worn and given by Mrs Rory McEwen

HONORÈ (England)

157 **Pink and silver informal evening coat.** English.
Honoré, 1965: of jacquard brocade: it is princess line
with fitted bodice and flared skirt: the sleeves are three-
quarter length. With it is a matching *handbag*.
Worn and given by Baroness Spencer-Churchill

CHARLES JAMES (USA)

Anglo-American designer who worked in London,
Chicago, New York and pre-War Paris. After World War
II, he re-opened in New York. He has a profound concern
with the techniques of cutting and draping, and has had a
widespread influence on the wholesale dress trade. There
is a complete documentation of his work at the Smith-
sonian Institute in Washington.

158 **Wedding dress.** English. Charles James, 1934:
made from cream satin: it is bias cut and fitted with high
neck trimmed with orange blossom and long sleeves: the
train is long and double.
Worn by Miss 'Baba' Beaton on her marriage to Mr Alec
Hambro, 6 November 1934, and given by Mrs
Alec Hambro

159 **Gold satin evening dress.** English. Charles
James, 1934: it has a low neckline, shoulder straps and
is bias cut to emphasize the figure.
Ref: 'I foresaw a new ideal and gave her the appear-
ance of having more bust and a wider pelvis than would
have been admired by the average fashionable woman of
the early thirties' (Letter from Charles James, 24 July
1971).
Worn and given by an anonymous lady

160 **Blue faille evening dress.** USA. Charles James,
1955. The dress has a strapless bodice and a tightly
draped bouffant skirt.
Ref: 'the angle at which the flounce is mounted on the
torso . . . was controlled by slashing the pattern vertically
every seven inches or so, so that geometrically the spread
of the hemline is no larger in the back than in the front.
In movement this creates a lightness . . . The overdraping
(depends) on carefully placed incisions which make it
possible to create the greatest tension in the silk when on
the body . . . The underbodice . . . is rather 'let out' in
front and firmly shaped on the sides and side back. The
construction of the inner bodice as to the grain of the
fabric used produced a silhouette unlike any of the
shaped clothes at the time I executed this design or, in
fact, at any time' (Letter from Charles James, *op. cit.*).
Worn and given by Mrs Ronald Tree

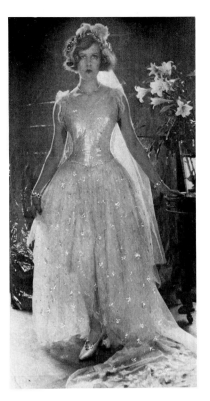

Lady Smiley, formerly Miss Nancy Beaton, wearing
her presentation dress by Hartnell, 1928. Cat. 153

JEANNE LAFAURIE (France)

Started designing clothes in 1928, and in 1937 transferred to 52 Faubourg St Honoré. She closed in 1953.

161 Yellow printed evening dress. French. Jeanne Lafaurie, about 1955: of yellow organdie patterned with darker flowers and re-embroidered with sequins and brilliants. It has a draped strapless bodice and a flaring skirt set into points at the low waist.
Worn and given by Mrs Loel Guinness

LA FERRIÈRE (France): Madame la Ferrière

Founded one of the main Parisian haute couture houses of the late 19th, early 20th century. Her clothes were among those shown by the Collectivité de la Couture in the Exposition Universelle 1900.

162 White brocade evening dress. French. La Ferrière, about 1900: with self coloured hydrangea pattern. The bodice is tight and draped and the skirt flared and trimmed with a flounce of silver spangled net. The net around the bodice is a modern replacement.
Worn by Her Majesty Queen Alexandra and given by Lady Lloyd

JEANNE LANVIN 1867–1946 (France)

Began by making hats and children's dresses, extending to adults in 1909. Her house became known for its graceful feminine clothes. In 1950, the design responsibility passed to Castillo (VS) and in 1963–64 to Jules François Crahay, born Liège, 1917, who trained in Liège and worked in his parents' atelier and with Germaine de Vilmorin and in 1959 with Nina Ricci. His clothes are simple in line with a feeling for colour and pattern.

163 Black evening dress. French. Jeanne Lanvin, Winter 1933–34: of double silk georgette. It is cross cut and fitted with the breast completely covered with silver sequins, which are also used to trim the streamers hanging from the shoulder straps.
Given by Mr Vern Lambert

164 Oyster embroidered evening dress. French. Jeanne Lanvin, 1957: of pure silk zibeline (Starron). It has shoulder straps, close-fitting bodice with a formal floral design in purple chenille and brilliants. The skirt is slightly gathered.
Worn and given by the Countess of Drogheda

165 Daisy patterned evening dress. French. Lanvin /Castillo, 'Ardele', May 1959: of white organdie with a yellow and white embroidered daisy design. It has a low neckline with fitted crossover bodice and elbow-length sleeves. The skirt is full and flared.
Worn and given by Mrs Loel Guinness

166 Blue embroidered evening dress. French. Lanvin/Castillo, 'Armide', December 1962: of pale and darker blue brocade. The high waisted bodice with high neckline and elbow length sleeves is embroidered in shades of blue, silver and pearl pendant crystal beads. The skirt is slightly flared. The *shoes* (Hellstern) are of matching material. They have an almond toe with fan shape trimming and a stiletto heel.
Worn and given by Mrs Loel Guinness

167 White evening dress. French. Lanvin/Castillo, 'Corfou', May 1962: of net with an appliqué pattern outlined in pearl strip. It has a round neckline, a tight bodice and full flaring skirt.
Worn and given by Mrs Loel Guinness

LUCIEN LELONG (France)

Founded his establishment in 1919 and, before his retirement in 1948, had done much as president of the Chambre Syndicale de la Couture to organize the whole French haute couture industry, which he managed to retain in Paris despite German pressure during World War II. Christian Dior, Pierre Balmain, Hubert Givenchy all designed for his house.

168 Cream evening dress. French. Lucien Lelong, about 1932: of faconné velvet with a floral design. It is low cut and semi-fitted with a flared peplum and flaring panels in the skirt.
Given by Mr Vern Lambert

169 Black evening dress. French. Lucien Lelong, 1946: a single strap draped sheath of silk velvet with a silk faille flounced skirt from the knees.
Worn and given by Stella Lady Ednam

LEONARD JOSEPH FORWARD LOOK (USA)

A boutique associated with Kenneth the New York Hairdresser.

170 Gold paper short evening dress. USA. Leonard Joseph Forward Look at Kenneth Boutique, New York, about 1968: a straight sleeveless shift with sequin side panels and yoke.
Worn and given by Princess Stanislaus Radziwill

LUCILE (England): Lucy Duff Gordon

Canadian born, began to make clothes in 1897 and before her partial retirement in the late 1920s had established major houses in London, Paris and New York. She was notable for her colour sense and her ingenious yet graceful styling. The Victoria and Albert Museum holds many of her designs and clothes.

171 Rose-pink cape. English. Probably Lucile, about 1915: a caped cloak of faconné velvet with rose design: the high gathered collar trimmed with satin roses.
Given by Mr Vern Lambert

MAINBOCHER (USA): Main Bocher

Was a fashion artist and became fashion editor and editor of *French Vogue*. He opened his own couture establishment in Paris in 1931, closing it in 1939 to re-open in New York, 1940, where it has just closed. Most of his clothes are restrained and almost severe, but in the pre-War period he encouraged the re-introduction of the embroidered dress.

172 Blue green evening dress. French. Mainbocher, 1935: in pale blue and green net, the heart shaped neckline and semi-circular gored skirt outlined with bands of gold and blue sequins.
Worn and given by Sybil Marchioness of Cholmondeley

173 Black embroidered evening dress. French. Mainbocher, about 1936: of net with top and apron front embroidered with gold sequin peasant type design. The full skirt is pleated.
Worn and given by Lady Glendevon

174 Evening jacket. French. Mainbocher, 1937: a straight cut hip-length jacket entirely embroidered in sequins with diagonal bands in navy blue and white.
Ref: a similar jacket is worn by the Duchess of Windsor in her engagement pictures by Cecil Beaton, where it is shown with a long white crepe dress with a sequin sash matching the jacket. (*American Vogue*, 1 June 1937, pp. 52–7, *British Vogue*, 9 June 1937, pp. 54–6).
Given by Mr Vern Lambert

175 Lime and mauve sequin evening dress. French. Mainbocher, about 1938: the cut is emphasized with the rows of sequins. It has a high neck, short sleeves with peaked shoulders and a gored flared skirt.
Worn and given by Lady Glendevon

176 Black embroidered evening dress. French. Mainbocher, about 1938: of satin embroidered with a large scale swirling Javanese type pattern in gold and sequins. It is fitted with a slightly flaring skirt and has a high neck and long sleeves.
Worn and given by Lady Glendevon

177 Black embroidered evening jacket. French. Mainbocher, Spring 1939: Fitted hip length jacket with pointed lapels and short sleeves of maroccain embroidered in Chinese type pattern in multi-colour sequins.
Worn and given by Lady Beit

178 Pink embroidered evening dress. French. Mainbocher, about 1939: of satin embroidered in sequins in shades of fuchsia and pink. It has a heart-shaped neckline, is high-waisted and has long sleeves full and pleated at the shoulder. The skirt flares from the centre back.
Worn and given by Lady Glendevon

179 Yellow blouse. USA. Mainbocher 1940: of embroidered lawn trimmed with bands of white work insertion. It has a high round neck with a bow in the centre front and short sleeves.
Worn and given by Miss Anita Loos

180 Pink blouse. USA. Mainbocher, 1940: of embroidered lawn trimmed with bands of white embroidered muslin. It has a high round neck and short sleeves.
Worn and given by Miss Anita Loos

181 Black and white evening dress. USA. Mainbocher, about 1951: of sablé de lyons: a straight softly draped dress leaving one shoulder bare.
Worn and given by Miss Eleanor Lambert

MICHAEL OF CARLOS PLACE (England): Michael Donellan

A London couturier, formerly Michael of Lachasse, who in 1953 opened up his own establishment in Carlos Place, formerly that of Peter Russell. It has just closed. It is known for its fine understated tailoring.

182 Black day outfit. English. Michael of Carlos Place, 'Deception', 1968: of silk and rayon. The sleeveless *dress* has a high round neck with black and white printed silk *scarf* and panelled skirt and wide buttoned waistband. The *jacket* is hip length with pointed turned down collar and turned back cuffs and black leather belt.
Given by Michael of Carlos Place

EDWARD MOLYNEUX (France)

Irish-born couturier who worked with Lucile before
World War I, and in 1919 opened his own establishment
at 14 rue Royale, which continued under his guidance
until 1939, continuing 1946–50, when he handed it over
to Jacques Griffe. One of the chief designers now is
John Tullis, his cousin. Molyneux clothes had a severe
understatement and purity of line.

183　　**Mauve evening coat.** French. Molyneux, about
1932: of georgette entirely covered with bugle bead
embroidery. It is straight cut with long gathered sleeves.
Given by Mr Vern Lambert

184　　**Black taffeta evening outfit.** French. Molyneux,
about 1936: The *dress* has crossed shoulder straps and a
full flared skirt fastening at the back with two rows of
small buttons. The *jacket* is waist-length and cutaway
with large round lapels and wide elbow length sleeves
gathered at the shoulder.
Worn and given by Miss Lynn Fontanne

185　　**Black satin evening dress.** French. Molyneux,
about 1938: the plain bodice has shoulder straps and
there is a triple flounced skirt.
Worn and given by Madame Miguel Angel Carcano

186　　**Pink silk evening dress.** French. Molyneux,
about 1938: with a single strap, draped bodice and a
gathered up bouffant skirt.
Worn and given by Stella Lady Ednam

JEAN MUIR (England)

Began as a fashion artist and then joined Jaeger as a
designer. She left to join 'Jane and Jane' and in 1960
opened her own establishment at 22 Bruton Street. Her
clothes have a classic timeless quality.

187　　**Green ciré jersey evening dress.** English.
Jean Muir, Autumn/Winter 1971: it has long full gathered
batwing sleeves, gathered straight into a tucked bodice
with collar band and front button fastening, and a full
skirt of narrow unpressed pleats: matching *hat*.
Ref: *British Vogue*, August 1971, p. 87.
Given by Miss Jean Muir

Edward Molyneux, 1953

NORMAN NORELL (USA)

Born Noblesville, Indiana, 1900, after working for stage
and screen, joined Hattie Carnegie and, in 1941, Andy
Traina, to form Traina Norell. Known for his subtle yet
simple styling.

188 **White crepe evening dress.** USA. Norman
Norell, 1966: Straight cut with full length straight sleeves
made of crepe: embroidered with broad silver sequin
bands.
Worn by Miss Eleanor Lambert at Truman Capote's Black
and White Ball, 1966, and given by her

189 **White and silver short evening dress.** USA.
Norman Norell, about 1966: a sleeveless sheath of crepe
embroidered with silver and white sequins. It has a white
satin tie belt.
Worn and given by Mrs Charles Revson

PAQUIN (France): Madame Paquin

Opened her maison de couture in 3 rue de la Paix in
1891. It moved to 120 Faubourg St Honoré, where
it remained until 1954. It was a large well organized house
and the first Paris establishment to have a London branch,
1912. Many of the sketches for designs of the 1920s and
30s are in the Victoria and Albert Museum, Department of
Prints and Drawings.

190 **Strawberry pink evening dress.** French. Paquin,
about 1924: a sleeveless tunic with slightly gathered
hemline of velvet with peaked bands embroidered in
Chinese style in blue and gold.
Worn and given by Sybil, Marchioness of Cholmondeley

191 **Black and white beaded evening dress.**
French. Paquin, about 1926–28: a tunic of brown net
embroidered in a design of interlinked circles.
Given by Madame Miguel Angel Carcano

192 **Brown chiffon evening dress.** French. Paquin,
about 1935: with a fichu draped top, softly falling puffed
sleeves and a cross cut skirt pleated at centre front and
back.
Given by Mr Vern Lambert

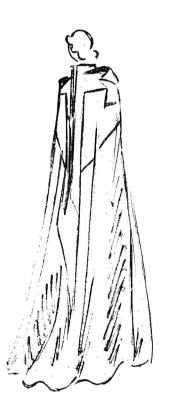

Evening cloak by Paquin 1938/9 Cat. 193.
Courtesy of Worth & Paquin Ltd

193 **Blue velvet evening outfit.** French. Paquin, 1938: the cutaway *jacket* is hip length and semi-fitted with high deep cut lapels and hip pockets. It fastens with three large paste studded buttons. Bands of chain and paste embroidery edge the collar and the cuffs. The *skirt* is long and slightly flared with a gored front. The *cloak* is full length and gored with wide turned-back revers, which together with the centre back are trimmed with paste and chain embroidery.
Ref: London, Victoria and Albert Museum, Department of Prints and Drawings, Paquin designs: Winter 1938–39, no. 1, vol. 104 (E.8645/46–1957).
Given by Madame Miguel Angel Carcano

JEAN PATOU (France)

Founded his house in 1914, and carried on from 1919 to his death in 1936, when he handed over to his brother-in-law Raymond Barbàs. His clothes were considered to be smart, workmanlike and well tailored. In 1963, the artistic direction was taken over by Michael Goma.

194 **Gold brocade evening jacket.** French. Jean Patou: 1933–34: with small floral pattern: hip-length with diagonal fastening and long tight sleeves.
Given by Mr Vern Lambert

195 **Pink beaded evening dress.** French. Jean Patou, about 1937: a sheath entirely embroidered with bugle beads emphasized with gold to suggest a draped top and skirt.
Worn and given by Mrs Leo D'Erlanger

PAUL POIRET (France)

Began to work with Jacques Doucet in 1895, continuing with the house of Worth until 1904, when he opened his own establishment. He worked with the most avant garde artists of the day and founded the Martine School of Art. His clothes show an opulent colour sense as well as an effective economy of cut: he tends to be ahead of his time. The Paris Centre de Documentation de Costume has a very complete collection of his work.

196 **Emerald green satin opera cloak.** French. Paul Poiret, about 1912: square-cut and held at the low waist with a gilt braid clasp and trimmed at the bottom with heavy gilt fringe. The long sleeves are of cloth of gold.
Given by Lady Gladwyn and worn by her mother Lady Noble.

Paul Poiret, 1931, from a photograph

197 **Black evening dress.** French. Paul Poiret, 'Samovar' about 1919: it has a semi-fitted v-necked sleeveless top embroidered in gold and black silk braid and a gathered skirt of black silk lace padded at the hips.
Given by Mr Vern Lambert

198 **Orange wool day dress.** French. Paul Poiret: about 1919: semi-fitted with skirt gathered at the hips and bat-wing sleeves rising from a slightly high waist. The neck, pockets, cuffs and right front are trimmed with black and white tasselled bands of braid.
Worn and given by an anonymous lady

199 **White satin evening dress.** French. Paul Poiret, about 1920: a single shouldered dress with loosely fitting bodice: the skirt asymmetrically draped with a train at the back. A spray of red and white artificial flowers trims the shoulder matching the scarlet chiffon facings of the dress.
Given by Mr Vern Lambert

200 **Black and white satin day dress.** French. Paul Poiret: 'La Flute', about 1925: it has a white satin long-waisted bodice with small square neck and long tight sleeves and a slightly flared black satin skirt. On the centre front is a flute motif embroidered in gold braid.
Worn and given by an anonymous lady

201 **Tartan silk day dress.** French. Paul Poiret, about 1925–26: in pink, grey and black check, it has a straight cut, low-waisted sleeveless bodice with square neck and black shoulder and hip yoke. Skirt panels are gathered on to the hip band.
Worn and given by an anonymous lady

THEA PORTER (England)

A painter, she began to make clothes in 1964. Known for her use of sheer and patterned fabrics.

202 **Black and white evening outfit.** English. Thea Porter, 1971: the *dress* of black chiffon, trimmed with gauging on the low-necked bodice, long sleeves and front of the skirt. The *cape* is double-tiered and made of white chiffon printed with a black peacock pattern (Sandra Munro).
Worn and given by Miss Jane Holzer

MARY QUANT (England)

Began to design clothes for Bazaar in 1955, swiftly moving into wholesale production with her 'Ginger Group' clothes which had a new easy fitting, informal styling.

203 **Black jersey dress.** English. Mary Quant, 'Ginger Group', 1964: low-waisted with a slightly gathered skirt, white collar-band and shirt sleeves: the edges contrast stitched.
Given by Miss Mary Quant

204 **Rust jersey dress.** English. Mary Quant. 1964: long-waisted with short contrast-stitched flared skirt. It has a centre front zip and a cream Peter Pan collar and turned back cuffs.
Given by Miss Mary Quant

205 **Maroon jersey dress.** English. Mary Quant. 1964: it is long-waisted with short contrast-stitched flared skirt. It has a centre front zip and a rounded collar and long sleeves.
Given by Miss Mary Quant

206 **Cream jersey dress.** English. Mary Quant, 1964: long-waisted with a short slightly gathered skirt. The high collar and bell-shaped sleeves are faced with blue contrast saddle-stitching and a decorative brass zip trims the neck and cuffs.
Given by Miss Mary Quant

REVILLE AND ROSSITER Ltd (England)

Founded in 1906 by William Wallace, Reville Terry and Miss Rossiter, both formerly of Jays. Their first establishment was in Hanover Square, moving to Grosvenor Square in 1927, where it later merged with the House of Worth. They were known for their attention to fashion detail and the fine materials they used.

206a **Wedding dress.** English. Reville, 1922: the *dress* is of silver lamé veiled with marquisette embroidered with English roses in a lattice pattern with pearls and brilliants. The *girdle* is of pearl studded silver cord and a trail of orange blossom hangs from the left side of the waist. The *train*, of silver and white duchesse satin, was embroidered with the emblems of Empire in pearls, brilliants and silver bullion. The silk net *veil* was worn with a tiara of orange blossom.
Ref: Illustrated London News, Wedding Number, 4 March 1922, pp. 293, 324.
Worn by H.R.H. Princess Mary, the Princess Royal, at her marriage to Viscount Lascelles, Westminster Abbey, 28 February 1922, and given by the Earl of Harewood

ZANDRA RHODES (England)

Studied at the Royal College of Art and went into textile designing. She began to design clothes on a professional scale after her 'discovery' by *American Vogue* in 1969.

207	**Yellow felt evening coat.** English. Zandra Rhodes, 1969: with stencilled oriental motif in red and black. It has a circular skirt from a high yoke, full gathered sleeves and a deep scalloped collar trimmed with beaded braids. It is worn with *shoes* (Charles Jourdain) of yellow patent trimmed with coloured inlays. They have flat heels and square toes.
Ref: British Vogue, October-December 1969, after p. 120.
Worn by Miss Irene Worth in the Royal Shakespeare Company production of 'Tiny Alice' by Edward Albee at the Aldwych Theatre 1970 and given by her

208	**Chiffon evening dress.** English. Zandra Rhodes, 1969: of white chiffon hand-printed with large circular motifs in blue and red. It is full gathered on to a high yoke and has very long full sleeves.
Ref: British Vogue, October-December, 1969, after p. 120.
Worn by Miss Irene Worth in the Royal Shakespeare production of 'Tiny Alice' by Edward Albee at the Aldwych Theatre, 1970, and given by her

NINA RICCI (France)

Of Italian origin, opened her salon, 20 rue des Capucines, in 1932 and died in 1970. It is being carried on by M. Robert Ricci. Known for its understated yet luxurious and feminine clothes.

209	**Black and white evening outfit.** French. Nina Ricci, 1969-70: black satin *dress* full length and slightly flaring with brassière top trimmed with a buckle tie at the back and worn with a white satin short-waisted, straight-cut, tailored *jacket*.
Worn by Madame Nina Ricci and given by Monsieur Robert Ricci

210	**Black sequin evening outfit.** French Nina Ricci, 'Blackout' 1969-70: straight cut and full length with a strapless *dress* with a long-waisted sequin bodice and straight black organza skirt covered with a flaring long-sleeved hip-length organza *tunic* with ostrich feather trimmed hem.
Worn by Madame Nina Ricci and given by Monsieur Robert Ricci

MAGGIE ROUFF (France)

Of couture background, her parents Besançon de Wagner ran Drecoll. She decided to study cutting in 1918 and opened her own house in 136 avenue des Champs Elysées, moving after World War II to 35 avenue Matignon.

211	**Pink graduated evening dress.** French. Maggie Rouff, about 1935: a cross-cut sheath with a low draped neckline in ripple satin dyed in graduated pinks.
Given by Mr Vern Lambert

PETER RUSSELL (England)

A London dress designer, active in the 1930s. His house closed in 1954.

212	**Tan poult evening coat.** English. Peter Russell, 1937: lined with mushroom colour. It has a high round neck, three-quarter sleeves and is princess-line with a full flaring skirt.
Worn by Mrs John Fraser (Ruth Vincent) and given by her son, Mr John Fraser

213	**Pink evening dress.** English. Peter Russell, 1937: of accordion pleated satin marocain held at breast and waist with bands of rhinestone and crystal embroidery.
Worn by Mrs John Fraser (Ruth Vincent) and given by her son, Mr John Fraser

YVES ST. LAURENT (France)

Trained at couture school and in 1953 joined Christian Dior, where, after Dior's death in 1956, he became chief designer, leaving to start his own house in 30 bis rue Spontini in 1962. He is notable for his creative vitality.

214	**Pale blue evening outfit.** French. Yves St. Laurent, no. 101, Autumn/Winter 1962: a knee-length straight cut *tunic* of grosgrain with low wide neck and elbow length sleeves trimmed with loops and knots of yellow beads. Worn with *trousers* of yellow satin and *shoes* (Roger Vivier), of pale blue satin with almond toe and medium high heel.
Ref: *L'Officiel,* October 1962, p. 95, shows the tunic in waist length version worn with a skirt.
Worn and given by Baroness Philippe de Rothschild

215 **Grey suede day outfit**. French. Yves St.
Laurent, no. 116, Autumn/Winter 1963: a hip-length
sleeveless *tunic* and *knickerbockers* and thigh length
boots.
Worn and given by the Baroness Philippe de Rothschild

216 **Leopard embroidered short evening coat**.
French. Yves St. Laurent, Autumn/Winter 1964: entirely
embroidered in a leopard design in gold chenille and
sequins (Rebé). The coat is straight with high round
neck and bracelet length sleeves.
Worn and given by Mrs Loel Guinness

217 **Yellow evening dress and jacket**. French.
Yves St. Laurent, no. 57, Autumn/Winter 1964: a straight
hip-length *jacket* and *skirt* of wild silk with a fitted *blouse*
of coloured floral silk embroidery on a white sequin
ground.
Worn and given by Princess Stanislaus Radziwill

218 **Black and grey short evening dress**. French.
Yves St. Laurent, no. 30, Autumn/Winter 1967: a sleeve-
less flaring sheath of black cigaline (Bucol) with
graduated grey to black sequin shape embroidery
(Vermont), trimmed at the hem with ostrich feathers.
Worn and given by Princess Stanislaus Radziwill

Yves St Laurent, 1971

SCHIAPARELLI (France): Elsa Schiaparelli

Italian born. Began her couture career in 1928 with
sweaters and sportswear. She worked with many of the
most advanced contemporary artists of her day and the
clothes from her house in 21 Place Vendôme and after-
wards from 4 rue de la Paix, are notable for their vivacious
originality. She closed in 1954. Albums of her designs
are in the Paris Centre de Documentation de Costume.

219 **Cravat pattern jumper**. French. Schiaparelli,
about 1928: in black and white wool knitted in a cravat
design by Armenian craftsmen.
'So I drew a large butterfly bow in front, like a scarf
round the neck—a primitive drawing of a child . . . the
bow must be white against a black ground and there will
be white underneath' (E. Schiaparelli, *Shocking life,*
1954, p. 47).
Given by Madame Elsa Schiaparelli as an example of the
design which started her career

Schiaparelli *c.* 1930

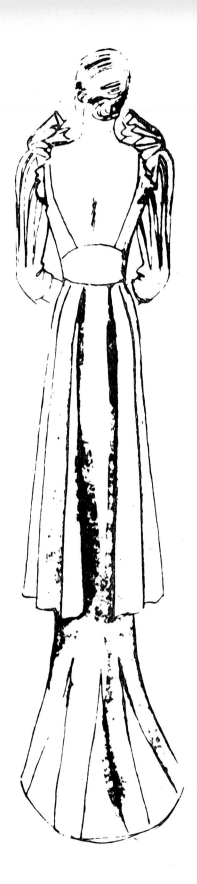

220 **Grey satin evening dress.** French. Schiaparelli, 1933: of grey satin with a v-neck and puff sleeves with pleated decorations and epaulettes. It is straight cut with pleated side panels and a small gored train.
Ref: Paris, Centre de Documentation de Costume, *Schiaparelli, Album, no. 2*, p. 339.
Worn and given by Mrs Alec Hambro

221 **Gold and silver evening cape.** French. Schiaparelli, 1933: made from looped metallic pile fabric. It is semi-circular, cut in one with the sleeves, and hip-length with a narrow band collar.
Ref: Paris, Centre de Documentation de Costume, *Schiaparelli, Album no. 2*, 1933, no. 2, p. 410: where it is shown in red 'Faille Cloque'.
Worn and given by an anonymous lady

222 **Black and white day outfit.** French. Schiaparelli, 1936: a white ripple satin *jacket* with black leaf appliqué decoration worn over a black halter necked ripple satin *dress* and black net *blouse* with white satin bow.
Ref: London, Victoria and Albert Museum, Department of Textiles, *Patent Office Registered Designs,* Schiaparelli no. 809777, 1936; Paris, Centre de Documentation de Costume, *Schiaparelli, Album, no. 11*, 1936, p. 79.
Worn and given by an anonymous lady

223 **Black jacket.** French. Schiaparelli, 1938: of black wool marocain, fitted and hip-length with large mirror embroidered motifs on the front.
Ref: London, Victoria and Albert Museum, Department of Textiles, *Album of registered designs,* Schiaparelli no. 826038; Paris, Centre de Documentation de Costume, *Schiaparelli, Album no. 19,* 1938, p. 49.
Worn and given by Miss Ruth Ford

224 **Pale blue evening outfit.** French. Schiaparelli, 1938: of pale blue marocain with printed motif in shades of purple 'tears': a slightly draped sheath with an asymmetrically arranged decolletage worn with a *mantle* in chiffon with a matching appliqué design and pink silk *gloves*. Based on a design by Salvador Dali (b.1904: Spanish surrealist painter), 'Tears'.
Ref: Paris, Centre de Documentation de Costume, *Schiaparelli, Album no. 19,* 1938, p. 124.
Worn and given by Miss Ruth Ford

Left
Evening dress by Schiaparelli, 1933. Cat. 220. Courtesy of Centre de Documentation de Costume, Paris

Right
Evening dress by Schiaparelli, 1937/38. Cat. 226. Courtesy of Centre de Documentation de Costume, Paris

Dress and blouse by Schiaparelli, 1936. Cat. 222. Courtesy of Centre de Documentation de Costume, Paris

Evening dress by Schiaparelli/Dali, 1938. Cat. 224. Courtesy of Centre de Documentation de Costume, Paris

225 **Black evening dress**. French. Schiaparelli, 1938: a fitted dress of black crepe with high neck and long sleeves padded to suggest a decorative skeleton torso and fastening with zips.
Ref: Paris, Centre de Documentation de Costume, *Schiaparelli, Album no. 19*, 1938, p. 128.
Worn and given by Miss Ruth Ford

226 **Evening outfit**. French. Schiaparelli, 1938: a fitted hip-length *jacket* of pink silk brocaded with circus horses, the buttons leaping acrobats, worn with a purple crepe *culotte dress*, the draped hem having openings for the feet.
Ref: 'The collections followed one another with definite themes . . . The most riotous and staggering collection was that of the circus' (E. Schiaparelli, *Shocking life*, 1954, p. 47), Paris, Centre de Documentation de Costume, *Schiaparelli, Album no. 19*, 1938, p. 41, though the jacket has a different pattern.
Given by Miss Ruth Ford and worn by her mother

227 **White evening dress**. French. Schiaparelli, 1953: made from organdie with appliqué apple-blossom on a shocking pink Thai silk foundation. It has a frill around the neckline, a long-waisted fitted bodice and a flared skirt.
Ref: Paris, Centre de Documentation de Costume, *Schiaparelli, Album no. 52*, 1953, p. 217.
Worn and given by the Duchess of Devonshire

MILA SCHÖN (Italy)

Yugoslav born designer with an haute couture establishment in Milan, which began to cater for international and commercial clientele in 1965. Her clothes are known for their fine technique and ingenuity of cut.

228 **White and silver evening outfit**. Italian. Mila Schön, 1966: a slightly flared sleeveless high-necked sheath of white net with a silver sequin yoke and undulating stripes of silver sequins and bugle beads. Over it is worn a *coat* of white silk matelassé with sequin collar and cuffs.
Worn and given by Princess Stanislaus Radziwill

229 **Beaded short evening dress**. Italian. Mila Schön, 1967: a high necked shift of striped red and green lamé overlaid with a bugle beaded net.
Worn and given by Princess Stanislaus Radziwill

MICHAEL SHERARD (England)

London couturier, who opened his house in 1946 and closed it in 1964.

230 **Black lace evening dress**. English. Michael Sherard, Spring 1958: trimmed with appliqué flowers. It has a wide v-neckline, fitted bodice, long sleeves and a full skirt with a short front and a trained back.
Given by Mr John Fraser and Mr Michael Sherard

231 **White satin evening dress**. English. Michael Sherard, Spring 1961: it has a deep v-neck and white cross-over bodice with wide kimono sleeves and a full wrap-over skirt arranged in unpressed pleats.
Given by Mr John Fraser and Mr Michael Sherard

232 **Black fur trimmed coat and stole**. English. Michael Sherard, Spring 1963: of mohair, fitted, with high round neck and sleeves trimmed with wide cuffs of black seal musquash, and a *stole* to match.
Given by Mr John Fraser and Mr Michael Sherard

SUSAN SMALL (England)

One of the longest established good class wholesale manufacturers of ready to wear; Maureen Baker, their designer started with them in 1947.

233 **Turquoise day outfit**. English. Susan Small, 1969: a wild silk redingote with small turned-down collar, and rouleau half-belt worn with matching *toque*, trimmed with a ribbon 'choux' (John Boyd).
Worn by H.R.H. The Princess Anne at the investiture of H.R.H. The Prince of Wales, on 1 July 1969 at Carnaervon Castle, and given by her

VICTOR STIEBEL (England)

South African born, London couture designer, whose salon was open 1932–40, 1945–63. During the latter period he worked in association with Jacqmar. His clothes have a restrained romanticism.

234 **Black marocain evening dress**. English. Victor Stiebel, 1937: a tucked sheath with shoulder straps.
Worn by Miss Cathleen Nesbitt in 'London After Dark' written and produced by Walter Hackett at the Apollo Theatre, 1937, and given by her

235 **Black evening dress**. English. Victor Stiebel, 1957: of black velvet with a low square neck, elbow-length sleeves, long waisted printed bodice and full skirt trimmed with black faille.
Worn and given by Miss Joyce Grenfell

TOLLMAN (France)

A Parisian couture house of the 1920s and 1930s.

236 **Blue lace evening dress**. French. Tollman, about 1929–30: a loose fitting sheath with halter neck-line, the front trimmed with frilled bands which reach to the flared panels round the hem.
Given by Mr Vern Lambert

EMMANUEL UNGARO (France)

Of Italian parentage, born in Aix-en-Provence, where his father was a tailor. He worked with Balenciaga for six years and joined Courrèges for his Autumn 1965 collection before founding his own house in 1966. His clothes have a firm spare tailored line often used in conjunction with patterned materials designed by Sonia Knapp.

237 **Orange gaberdine day dress**. French. Ungaro, 1966: a flaring tunic with a high band collar, long sleeves and high yoke continuing into side panels with two vertical pockets.
Worn by the late Mrs Stavros Niarchos and given by Mr Stavros Niarchos

238 **Check coat**. French. Ungaro, 1966: of pure wool with a jacquard woven pattern of large checks shaded blue to grey on a white ground (Nattier). It is flared and double-breasted with a small turned down half collar, horizontal pockets and a half belt.
Worn by the late Mrs Stavros Niarchos and given by Mr Stavros Niarchos

239 **Printed calf day outfit**. French. Ungaro, Spring 1967: a *dress* with a knitted white jersey (Racine), long waisted top with a printed calf-skin centre band and flared skirt. Worn with a *coat* of brown and white printed calf-skin with a small round turned-down collar and white kid button flaps and belt.
Worn and given by Princess Stanislaus Radziwill

240 **Grey and striped day outfit**. French. Ungaro, 'Parallèle', 1967: a grey, sleeveless flared *dress* with a channel seamed bodice worn with a waist-length *jacket* in horizontal grey and white striped wool (Nattier), with a small white turned-down collar.
Worn by the late Mrs Stavros Niarchos and given by Mr Stavros Niarchos

241 **Green and white day outfit**. French. Ungaro, 1967: of white wool with a narrow green stripe (Nattier). The *dress* is slightly flared and has a high round neck and is sleeveless with narrow cut shoulders. The *coat* has a rounded collar and is double-breasted with a waist-band and rounded breast pocket.
Ref: L'Officiel, September 1968, p. 74.
Worn by the late Mrs Stavros Niarchos and given by Mr Stavros Niarchos

242 **Blue and brown day outfit**. French. Ungaro, 1968: a flared *skirt* of wool with large brown and blue pattern (Nattier), worn with a brown suede belted double-breasted *waistcoat* and a flared belted *coat* of the printed wool, double-breasted with asymmetrical curved lapel and low curved patch pockets.
Ref: L'Officiel, September 1968, for coat design; and for fabric design.
Worn and given by Princess Stanislaus Radziwill

VALENTINA (USA): Mrs George Schlee

Russian born New York designer, began to make clothes in the early 1930s and is known for her simple yet dramatic clothes in supple fabrics.

243 **Orange evening dress**. USA. Valentina, 1939: of tree bark crepe. It has a round neck, centre front fastening and full flaring skirt. The wide kimono sleeves are of Indian silk, orange with gilt striped embroidery, and match the wide belt.
Worn and given by Miss Lynn Fontanne

244 **Shaded grey evening outfit**. USA. Valentina, 1960: of three shades of grey georgette with a halter neckline and very full flaring skirt. Worn with a matching bolero *jacket*.
Worn and given by Mrs George Schlee

VALENTINO (Italy)

245 **Black velvet short evening dress**. USA. Valentino, 1969: with brilliant and braid openwork embroidery forming epaulettes and waist-band.
Worn and given by Princess Stanislaus Radziwill

Vionnet, 1953.

MADELEINE VIONNET (France)

Born 1875 in Aubervilliers and worked in London with
Kate Reilly and then with Bechoff David, Callot Soeurs
and Douçet before opening her own house in 1912.
She closed in 1914 and re-opened in 1918, moving to
50 avenue Matignon. She is known as the pioneer of the
bias cut dress, which moulds the body without restriction
and flows with its movement. She retired in 1939. The
documentation of her house is in the Paris Centre de
Documentation de Costume.

246 **Lilac lawn day dress.** French. Vionnet,
'La Fleur' 1920: with short sleeves and v-neck: the skirt
arranged in rows of petal flounces with appliqué floral
design.
Ref: Paris, Centre de Documentation de Costume,
Vionnet Photograph Album, Model 398, p. 12.
Worn and given by Sybil, Marchioness of Cholmondeley

247 **Orange evening dress.** French Vionnet, 'Coq
de Roche', about 1930: of orange crepe Romaine: it has
a large soft collar, full sleeves and flowing gored skirt,
wrapped over and held with a sash.
Worn by the Baroness Robert de Rothschild and given
by the Baroness Elie de Rothschild

WORTH (France)

Founded by the English Charles Frederick Worth in 1858
and after his retirement in the late 1880s the house at
7 rue de la Paix was carried on by his sons Jean Philippe
and Gaston and his grandsons Jean Charles and Jacques.
It was closed after World War II. There were branches of
Worth in all major capitals. It was known for the
splendour of its clothes and dressed most of the courts
in Europe. The albums of designs are in the Victoria and
Albert Museum Library and Department of Prints and
Drawings.

248 **Pink velvet evening dress.** French. Worth,
about 1898–1901: of pale pink velvet. It has a low draped
bodice; the short sleeves, corsage and skirt border are
trimmed with brilliants and star patterned braid.
The frilled petticoat is a modern replacement.
Worn by Princess Nicholas of Greece and given by the
Duke and Duchess of Kent

249 **Cream satin evening dress.** French. Worth,
about 1919: satin with floating chiffon panels and a
draped sash at the high waist. It is trimmed with tasselled
ropes of pearls and brilliant embroidery embellishes the
draped skirt.
Worn by the Duchess of Portland and given by Lady
Victoria Wemyss

UNATTRIBUTED DRESSES

250 **White embroidered lawn day dress.** French. About 1914. It is straight cut with a high waist, small triangular collar and elbow-length sleeves. A panel of cream lace with a fringed edge trims the front and back. The ribbon belt is of black velvet.
Given by the Hon. Mrs J. J. Astor

251 **Silver brocade evening coat.** English or French. About 1938: with front border and epaulettes of the short puffed sleeves in silver and white bead embroidery. It has an edge-to-edge closure, fitted and trained.
Worn and given by H.M. the Queen Mother

252 **Black lace dress.** French. About 1957: with low neck, three-quarter length sleeves, long torso bodice and gathered skirt.
Worn and given by Mrs Leo D'Erlanger

253 **Turquoise suede day outfit.** English. Sydney Smith, 1969: a fringed waistcoat and mini-skirt.
Worn and given by the Countess of Pembroke

EXOTIC, FANCY AND THEATRICAL DRESS

254 **Persian costume.** Persian. A mid-19th century green and gold brocade *jacket* with printed cotton facings, and red satin *trousers*.
Worn by and given by Alice Astor von Hofmannsthal

255 **Fancy dress.** English. 'Duchess of Savoia' 1897: of silver satin, the pattern outlined in pearls, brilliants and silver strips. The dress has a low round neckline, slashed puff sleeves and a jewelled belt. It is worn with a wide lace *ruff*.
Ref: Queen, 10 July 1897, p. 73; description of the Duchess of Devonshire's Ball.
'The train of cloth of silver, lined with pale blue satin and embroidered with pearls', and the embroidered sleeves from elbow to wrist are now missing.
Worn by the Duchess of Portland as Duchess of Savoia at the Duchess of Devonshire's Fancy Dress Ball, 2 July 1897 and given by Lady Victoria Wemyss

256 **Cat mask.** English. About 1950: in lace and sequins.
Given by Stella Lady Ednam

257 **Fancy dress.** French. 'Harlequin'. Schiaparelli, 1951: a short *jacket* in blue, yellow, black and white triangular patchwork with a yellow pleated muslin *ruff* and knee-length white satin *trousers*.
Designed by Givenchy for Stella Lady Ednam as Harlequin at the Bestigui Ball, Venice, 4 September 1951

258 **Caftan.** Moroccan. October 1963: of pink chiné satin covered with pale pink lurex printed overdress.
Given to Princess Stanislaus Radziwill by the King of Morocco and given by her

M. BERMAN LTD (England)

Theatrical costumiers founded by the grandfather of the present head of the firm about 1900. They have establishments in London and Hollywood and have been in their present premises in Irving Street since 1912. They started as military tailors.

258a **'My Fair Lady' Ascot dress.** English. Designed by Cecil Beaton 1963: of black and white satin. Designed for the Ascot scene in the film 'My Fair Lady', 1963.
Made and given by M. Berman Ltd

MEN'S CLOTHES

259 **Green silk smoking suit.** English. 1906: of green and red printed foulard scarf squares. The *jacket* is double-breasted and the *trousers* are straight-cut.
Worn by Mr Jack Eden and given by the Earl and Countess of Avon

260 **Silk waistcoat.** English. About 1906–10: of green and brown check silk, double-breasted with notched lapels.
Worn by Jack Eden and given by the Earl and Countess of Avon

261 **Plaid waistcoat.** English. 1906–10: of beige wool with brown and blue checked stripes. It is double-breasted with button-down notched lapels.
Worn by Sir William Eden and given by the Earl and Countess of Avon

262 **Velveteen smoking suit.** English. About 1910: with black and green stripes; double-breasted jacket and straight cut trousers.
Worn by Jack Eden and given by the Earl and Countess of Avon

263 **Smoking suit.** English. About 1925: of maroon tussore with a white diamond design: a cut-away *jacket* with shawl collar, double link fastenings and straight cut *trousers*.
Worn by the Marquess of Anglesey and given by Mr Curtis Moffat

264 **Space suit.** French. Pierre Cardin, 1967: a white jersey *tabard* with chrome zip fastening down the front and at the breast pocket. Worn with a *belt* of black leather with a lead buckle, black rib polo necked *sweater* and black jersey ski *trousers* and black patent ankle *boots* with circular pattern tops.
Given by Pierre Cardin

MR FISH (England): Michael Fish

Creative men's-wear designer, began his career fifteen years ago. He opened his Clifford Street establishment in 1967.

265 **Brocade suit.** English. Mr Fish, October 1970: the semi-fitted *jacket* of blue, black and silver brocade has a collarless neckline and fastens with a braid clasp. The *trousers* are of blue cotton doeskin with a black satin stripe. The roll-neck *shirt* is black with a trimmed centre front with a fish *brooch* (Kenneth Lane).
Worn and given by Mr Fish

HATS & HEAD-DRESSES

266 **Sable hat.** French. Caroline Reboux, about 1865–70: trimmed with pale blue grosgrain ribbon and sable tails.
Worn by the Empress Eugénie and given by Sybil, Marchioness of Cholmondeley

267 **Lilac chiffon toque.** English. Mid–1930s: trimmed with violets.
Worn by H.M. the late Queen Mary and given by the Earl of Harewood

268 **Iridescent green feather coolie hat.** French. Probably Caroline Reboux, mid–1930s.
Worn and given by Sybil, Marchioness of Cholmondeley

269 **Black felt hat.** English. Maison St. Louis. About 1932: a brimmed cloche trimmed at the front with gold wings.
Worn by the late Lady Violet Bonham Carter and given by the Hon. Mrs Raymond Bonham Carter

270 **Crimson hat.** French. Probably Caroline Reboux, about 1932: of pedal straw, trimmed with velvet poppy. It has a low crown and a wide brim.
Worn and given by Sybil, Marchioness of Cholmondeley

271 **Navy osprey trimmed cap.** French. Probably Caroline Reboux, about 1932.
Worn and given by Sybil, Marchioness of Cholmondeley

272 **Lime green pillbox.** French. Madame Suzy about 1938: trimmed with hackle feathers and black sequined net.
Worn and given by Mrs Leo D'Erlanger

273 **Straw 'postillion' hat.** French. Madame Suzy, about 1938: trimmed with pale blue and black velvet ribbon.
Worn and given by Mrs Leo D'Erlanger

274 **Black 'top' hat.** French. Schiaparelli, 1938: of felt with lace frilled brim.
Worn and given by Miss Ruth Ford

275 **Cream toque.** English. Probably Marjorie Somerset, 1940s: draped with net and trimmed with a mount of clipped ostrich feathers.
Worn by H.M. the late Queen Mary and given by the Earl of Harewood

276 **Black toque.** English. Probably Marjorie Somerset, 1940s: draped with chiffon and trimmed with a mount of clipped ostrich feathers.
Worn by H.M. the late Queen Mary and given by the Earl of Harewood

277 **Pale blue toque.** English. Marjorie Somerset, 1940s: draped with marocain and trimmed with a mount of matching swan feathers.
Worn by H.M. the late Queen Mary and given by the Earl of Harewood

278 **Cream toque.** English. Probably Marjorie Somerset, 1940s: draped with chiffon and trimmed with a mount of matching sheared clipped ostrich feathers.
Worn by H.M. the late Queen Mary and given by the Earl of Harewood

279 **Purple toque.** English. Probably Marjorie Somerset, 1940s: draped with crepe and trimmed with a mount of matching clipped ostrich feathers.
Worn by H.M. the late Queen Mary and given by the Earl of Harewood

280 **Pink and white feather coolie hat.** French. Probably Caroline Reboux, late 1940s.
Worn and given by Sybil, Marchioness of Cholmondeley

281 **Brown and orange feather beret.** French. Probably Caroline Reboux, late 1940s.
Worn and given by Sybil, Marchioness of Cholmondeley

282 **Tricorne hat.** French. Caroline Reboux, 1955: of black velour trimmed with braid.
Worn and given by Lady Gladwyn

283 **Breton.** French. Balenciaga, 1958: of parabuntle straw with a black ciré ribbon.
Worn and given by Mrs Loel Guinness

284 **Black sheared ostrich cap.** French. Balenciaga, late 1950s: trimmed with pompoms.
Worn and given by Mrs Loel Guinness

285 **Black varnished leaf bandeau.** French. Balenciaga, late 1950s:
Worn and given by Mrs Loel Guinness

286 **Garden hat.** English. About 1950–60: wide brimmed, made from straw braid trimmed with a green and blue printed chiffon scarf.
Worn and given by the Viscountess Cranborne

287 **White organdie hat.** French. Balenciaga, about 1960.
Worn and given by Mrs Loel Guinness

288 **White leather domed helmet.** French. Balenciaga, early 1960s.
Worn and given by Mrs Loel Guinness

289 **White, black spotted 'bowler'.** French. Castillo, 1961: of organza.
Worn and given by Mrs Loel Guinness

290 **White broad brimmed hat.** French. Givenchy, 1961: of sisal straw with petersham band.
Worn and given by Princess Stanislaus Radziwill

291 **Cream broad brimmed hat.** French. Courrèges, 1961: of parabuntle straw with petersham band.
Worn and given by Princess Stanislaus Radziwill

292 **Pale green wide brimmed cloche.** French. Mizza Bricard at Christian Dior, 1961: raffia trimmed and made of parabuntle straw.
Worn and given by Lady Abdy

293 **Black wool gauze beret.** French. Mizza Bricard at Christian Dior, 1961.
Worn and given by Lady Abdy

294 **Black beret.** English. Simone Mirman, 1962: of pedal straw.
Worn and given by Princess Stanislaus Radziwill

295 **White leather hat.** French. Balenciaga, mid-1960s.
Worn and given by Mrs Loel Guinness

296 **Brown suede helmet.** French. Balenciaga, mid-1960s: trimmed with small self bow.
Worn and given by Mrs Loel Guinness

297 **Black velour beret.** French. Balenciaga mid-1960s.
Worn and given by Mrs Loel Guinness

298 **Black organza toque.** French. Balenciaga, mid-1960s.
Worn and given by Mrs Loel Guinness

299 **Cream straw hat.** French. Courrèges, Spring/Summer 1965: of cream pedal straw with a flat crown and a wide brim
Worn and given by Princess Stanislaus Radziwill

300 **Brown nutria and chamois turban.** French. Mizza Bricard at Christian Dior, 1966.
Worn and given by Lady Abdy

301 **Black rose hat.** Mizza Bricard at Christian Dior, 1968: a square scarf of organza trimmed with roses and attached to a pink draped turban.
Worn and given by Lady Abdy

302 **Green camelia hat.** French. Mizza Bricard at Christian Dior, 1969: a green taffeta triangular scarf, trimmed with flowers and mounted on a cap.
Worn and given by Lady Abdy

303 **Black straw hat.** French. Givenchy, Spring 1970: with wide brim and high crown.
Worn and given by Mrs Paul Mellon

304 **Blue straw hat.** French. Givenchy, Spring 1970: with wide brim and high crown.
Worn and given by Mrs Paul Mellon

305 **Black 'Mounty' hat.** English. Simone Mirman, 1971: of black felt with eyelet trimming.
Given by Simone Mirman

306 **Two bird of paradise plumes:** about 1909–14.
Given by Lady Gladwyn, used by her mother Lady Noble

307 **Bird of paradise plume** mounted on black satin headband. About 1909–14.
Given by Lady Gladwyn, used by her mother Lady Noble

308 **Orange osprey aigrette.** French. About 1911–14: of orange osprey.
Given by Sybil, Marchioness of Cholmondeley

309 **Pink osprey aigrette.** French. About 1911–14.
Given by Sybil, Marchioness of Cholmondeley

310 **Fuchsia feather aigrette.** About 1911–14: with a fuchsia and blue chiffon headband.
Given by Lady Gladwyn and worn by her mother Lady Noble

311 **Black feather aigrette** mounted on green wired headband. About 1911–14.
Given by Lady Gladwyn and worn by her mother Lady Noble

312 **Silver wire aigrette.** Indian. About 1925.
Given by Sybil, Marchioness of Cholmondeley

SHOES (excluding those en suite with outfits)

313 **Black patent shoes.** Italian. About 1920: with an inlaid design of beige grosgrain. They have a lace ankle bar fastening, a square toe and a low heel.
Worn and given by Sybil, Lady Cholmondeley

314 **Brown glacé kid shoes.** French. Yanturni, about 1920: with punched decoration. They lace up and have a flat leather heel.
Worn and given by Mrs C. G. Lancaster

315 **Silver kid evening shoes.** Italian. Nicolini Antonio, about 1923: with high topped vamp, almond toe and lotus heel.
Worn by Mrs John Fraser (Miss Ruth Vincent) and given by her son Mr John Fraser

316 **Brown glacé shoes.** Italian. Nicolini Antonio, about 1923: double bar fastening, almond toe and low heel.
Worn by Mrs John Fraser (Miss Ruth Vincent) and given by her son Mr John Fraser

317 **Burgundy calf ankle boots.** French. Bunting, Summer 1938: with curved matching leather lizard instep: lace up fastening and medium squared-off heel.
Worn by Mrs John Fraser (Miss Ruth Vincent) and given by her son Mr John Fraser

318 **Embroidered pink satin evening shoes.** French. Christian Dior, about 1952–54: encrusted with coloured pastes and gold braid. They have an almond toe, a sling-back and a medium heel.
Worn and given by Mrs Loel Guinness

319 **Gold kid evening sandals.** English. Rayne, 1957: with diamanté decoration at the open toe, crossed instep straps and a high stiletto heel.
Worn and given by Mrs Peter Palumbo

320 **Embroidered pink satin evening shoes.** French. Dior/Vivier, about 1958–60: encrusted with gilt, rhinestones and pink brilliants: pointed toe and high stiletto heel.
Worn and given by Mrs Loel Guinness

321 **Dark pink satin evening shoes.** French. Christian Dior, about 1960: with pointed toe trimmed with a bow and a high stiletto heel.
Worn and given by the Baroness Elie de Rothschild

322 **Embroidered oyster evening shoes.** French. Dior/Vivier, 1958–62: of grosgrain embroidered with coral pastes and bronze beads: exaggerated Louis heel and Turkish toe.
Worn and given by Viscountess Lambton

323 **Pink satin evening shoes.** French. Boutique Mancini, about 1961: with a paste bar trimming, and chisel toe. The heels are of medium height.
Worn and given by the Baroness Alain de Rothschild

324 **Black satin evening shoes.** René Mancini, about 1961: with a diamanté trimmed bow. They have a chisel toe and a stiletto heel.
Worn and given by the Baroness Elie de Rothschild

325 **Maroon satin evening shoes.** Italian. Loria Roma, September 1961: with self-coloured loop and brilliant trim, pointed toe and narrow Louis heel.
Worn and given by Mrs Leo D'Erlanger

326 **Black satin evening shoes.** French. Roger Vivier, about 1961: the chisel toe trimmed with a square paste buckle. The heels are of medium height.
Worn and given by Princess Stanislaus Radziwill

327 **Navy kid shoes.** French. Roger Vivier, about 1961–62: with a silk bow on the chisel toe and medium heel.
Worn and given by the Princess Stanislaus Radziwill

328 **Embroidered brown satin evening shoes.** French Dior/Vivier, about 1962: encrusted with bronze and lilac beads and bronze strips. They have a very pointed toe and an exaggerated Louis heel.
Worn and given by Madame Lilia Ralli

329 **Peach satin evening shoes.** French. Dior/Vivier, 1962: with almond toes trimmed with a self-material bow and stiletto heels.
Worn and given by the Baroness Philippe de Rothschild

330 **Egyptian style sandals.** English. Designed by Oliver Messel, 1962–63: of orange silk with gold and white appliqué decoration. They have a lotus trimming on the front, open toes and wedge heels.
Worn by Elizabeth Taylor as Cleopatra in the film 'Cleopatra', 1963, given by M. Berman Ltd

331 **Embroidered fuchsia satin evening shoes.** French. Christian Dior, about 1962–64: the almond toe decorated with gold and green beads, and low heels.
Worn and given by Mrs Loel Guinness

332 Turquoise satin evening shoes. French.
Anglissano, about 1961–64: with a diamanté trimmed
rosette at the pointed almond toe and high heels.
Worn and given by Mrs Leo D'Erlanger

333 Blue velvet evening shoes. French. Anglissano,
1962–64: with pointed almond toe and medium high
heel: there is a heart motif at the toe.
Worn and given by Mrs Leo D'Erlanger

334 Green and gold brocade evening shoes.
French. Christian Dior, about 1962–64: they have a
rounded almond toe and flat heel.
Worn and given by Mrs Loel Guinness

335 Fuchsia satin evening shoes. French. A.
Grellini, about 1962–64: with diamanté buckle, almond
toe and high heel.
Worn and given by Mrs Leo D'Erlanger

336 Black satin evening shoes. Paris. Georgette,
about 1964: with crimson velvet medium stiletto heel,
pointed toe with diamanté buckle.
Worn and given by Lady Ann Tree

337 Black patent shoes. French. Roger Vivier,
about 1965: the almond toe trimmed with a silver buckle.
They have a low cuban heel.
Worn by the late Mrs Stavros Niarchos and given by
Mr Stavros Niarchos

338 Blue kid shoes. French. Roger Vivier, about
1965: the almond toe trimmed with a white buckle with
a gold rim. They have a low cuban heel.
Worn by the late Mrs Stavros Niarchos and given by
Mr Stavros Niarchos

339 Brown patent and beige suede ankle boots.
Italian. Dal & Co, 1968–70: side buttoning with stacked
heel, square toe.
Worn and given by Princess Stanislaus Radziwill

340 Shoe lasts. English. Hobbs & Lewis Ltd,
Kettering: for shoes made for H.M. the late Queen Mary.
Given by Mr Edward Rayne

ACCESSORIES

341 Topless bathing suit. USA. Rudi Gernreich,
1964: of black and white check wool with black straps.
This was one of the first topless bathing costumes.
Given by Mrs Smith, USA

342 Boa. English. About 1910: of curled white
ostrich feathers.
Given by Sybil, Marchioness of Cholmondeley

343 Dressing gown. French. Helene Yrand, 1938:
of raspberry coloured wool. It is full-length and fitted
with a triangular collar and batwing sleeves. The buttons
are ceramic.
Worn and given by Mrs Leo D'Erlanger

344 Black taffeta fan. English. Late 19th century:
painted with cupids, orange-blossom and 'Georgie'
in gold.
Given by Stella, Lady Ednam

345 Black satin fan. French. Late 19th century:
with 18th century style painted grisaille scene of lady
and gentleman crossing a stream.
Given by Stella, Lady Ednam

346 Bed jacket. English. About 1936: it is semi-
circular and made of pink georgette trimmed with
matching ostrich feathers.
Worn by Millicent, Duchess of Sutherland and given by
Stella, Lady Ednam

347 Diagonal striped jerkin. English. Bolton &
Kaffe, 1971: of brown and green, with rust and green
patterned welts. It fastens with a lace at the neck.
Given by Kaffe Fassett

348 Black lace gloves. French. Suzanne Talbot
about 1936–38: wrist length.
Worn and given by an anonymous lady

349 Shocking pink gloves. French. Schiaparelli,
1937: long, in cotton doeskin, with diagonal bands in
vermilion.
Worn and given by Miss Ruth Ford

350 Black suede gloves. French. 'Alcazar',
Galeries Lafayette, about 1938: with wrist-length cuffs
trimmed with curled black ostrich feathers.
Worn and given by an anonymous lady

351 Black suede gloves. French. Appin, about
1938: trimmed with gold kid: they are elbow-length with
thumb and first finger divisions only.
Worn and given by an anonymous lady

352 Blue and white calf handbag. French. Roger
Vivier, about 1965: rectangular with gilt and blue
trimmed handle.
Used by the late Mrs Stavros Niarchos and given
by Mr Stavros Niarchos

353 Black lace mittens. French. Suzanne Talbot,
about 1936–38: with slightly flared cuffs.
Worn and given by an anonymous lady

354 **White satin mittens.** French. Schiaparelli,
1938: of white satin, with thumb slit-fastening with
multi-coloured bead buttons.
Worn and given by Miss Ruth Ford

355 **Necklace.** French. Schiaparelli, 1938: gilt
pine-cone attached with purple velvet bows to a yellow
grosgrain neckband.
Worn and given by Miss Ruth Ford

356 **Pearl and brilliant dress ornament.** English.
Probably 1920s.
Worn by H.M. the late Queen Mary and given by the
Earl of Harewood

357 **Black lace parasol.** French. Suzanne Talbot,
about 1938: it is adjustable and folding.
Used and given by an anonymous lady

358 **White mini skirt.** USA. Bendel, 1966: of
pique, pleated, with wrapover front fastening and two
buckled straps.
Worn and given by Miss Jean Shrimpton

359 **Brown umbrella.** French. 'ONM'. About 1965:
with lizard crook handle: walking length.
Used by the late Mrs Stavros Niarchos and given by
Mr Stavros Niarchos

360 **Black underwear.** French. About 1940: a
chiffon *slip* gored, trimmed with black lace: *panties* of
black satin similarly trimmed.
Worn and given by Mrs Loel Guinness

361 **Mourning veil.** English. Probably 1940s, of
black silk organza.
Worn by H.M. the late Queen Mary and given by the
Earl of Harewood

362 **Lilac tweed knitted waistcoat.** English.
Bolton & Kaffe, 1971: of sea urchin pattern, lilac, yellow
and black, hand-flame knitted shetland wool with
patterned welt.
Given by Kaffe Fassett

H.R.H. The Duchess of Kent's wedding dress by John
Cavanagh, 1961. Cat. 45. Courtesy of John Cavanagh,
drawn by Alfredo Bouret

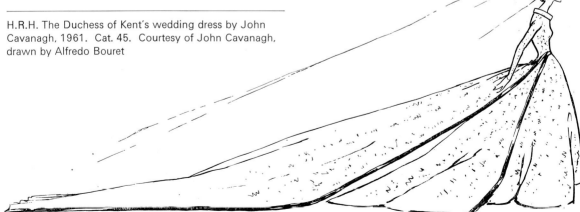

Additions to Catalogue since mid-August

ADRIAN (USA): Gilbert Adrian

Born Nangatuck, Connecticut and went to School of Fine and Applied Arts, New York. Worked as a designer for variety and the silent screen and by 1928 had joined Metro Goldwyn Mayer. He designed for most of the Hollywood stars of the 1930s and is known for having brought a sense of high fashion to the screen. He died in 1959.

363 Beaded maroon evening dress. USA. Adrian, about 1945.
Worn and given by Mrs Paul Gregory (Janet Gaynor Adrian)

BALENCIAGA (continued)

363a Black coat. French. Balenciaga, about 1960: of face cloth with a small turn-down collar, three-quarter kimono sleeves and a high-waisted yoke into which are inserted pocket flaps. Probably worn with a straight skirt now missing.
Given by Mr David Watts of Jaeger

364 Pink matelassé trouser suit. French. Balenciaga, about 1966: a straight-cut *tunic* with a round neck and three-quarter sleeves, worn with tapering *trousers*.
Worn and given by Countess Bismarck

365 Trouser suit. French. Balenciaga, about 1966: the *tunic* of black floral flocked organza mounted over pink, has a round neck and is slightly flared. It has short half-raglan sleeves. It is worn with tapering *trousers*, which are of sheer nylon over pink wild silk, and with a black satin *sash*.
Worn and given by Countess Bismarck

366 White trouser suit. French. Balenciaga, about 1966: of silk gaberdine: a straight-cut round-necked *tunic* with three-quarter sleeves and a pair of matching tapered *trousers*.
Worn and given by Countess Bismarck

367 Check coat. French. Balenciaga, about 1968: of orange, lilac and green checked wool double-faced with orange. It is straight cut with a plain round neck and a raglan sleeve.
Worn and given by Countess Bismarck

BALMAIN (continued)

368 Brown velvet suit. French. Balmain about 1945–46: straight cut *jacket* with black tassel and sequin frog trimming and slightly flaring *skirt*.
Worn by Gertrude Stein and given by Mr Harold L. Knapik

JOHN BATES (England)

Born Newcastle, trained at and began to design and make for a Knightsbridge couture house 1957–60, also selling sketches to Belinda Bellville. In 1960 he set up his own dress house in association with Jean Varron and in 1969 added a 'Capricorn' range for coats and suits. His designs, intentionally for the 'girl in the street', have an unusual distinction.

369 Day outfit. English. John Bates at Jean Varron, 1971: the *dress* in black and white tweed has a short-sleeved, high-necked, high-waisted bodice, a gathered knee-length over-skirt and full-length skirt. It is worn over a cream, linen and rayon *blouse* with a high flared collar and long sleeves with flaring cuffs and with black jersey *cap* and black knee-length suede zip-fastening *boots*.
Given by Mr John Bates

BIBA (England): Barbara Hulanicki

A fashion artist trained at Brighton Art School she started Biba as a postal boutique in 1964. Biba opened their first shop in Kensington and moved to larger premises in Kensington Church Street and now have a department store in Kensington High Street, opened in 1969. They aim at producing a complete co-ordinated original 'look'.

370 **Black velvet day outfit.** English. Biba, 1971: a single-breasted *jacket* with flared back and a narrow ankle-length *skirt* worn with matching *hat* in French embossed velvet.
Given by Biba

371 **Black velvet girls dresses.** English. Biba, 1971: with round neck and long flared sleeves. They are ankle length. Worn with matching *bonnets* in French embossed velvet.
Given by Biba

CARDIN (continued)

372 **Evening dress.** French. Cardin, 1970. Full-length sheath dress, of flame red chiffon with huge petal sleeves. Slit up centre front: matching *shoes* and *stockings* (Mancini).
Worn and given by Mrs Charles Wrightsman

HATTIE CARNEGIE (USA) (Mrs John Zanft): Henriette Kannengiser

Born in 1889 in Vienna; died in 1956. Emigrated to USA and began in New York as a milliner 1909. She had opened her own dress house before 1919 and gradually expanded her range, going into sports clothes and ready-to-wear after 1929. She adapted French styles for American market and was known for her use of fine fabrics in simple styles, her stress on the suit and the general understatement of her designs.

373 **Beaded brocade dress.** USA. Hattie Carnegie, 1955: In red and gold Indian pattern brocade, the design emphasized with sequins and beads. It is a sheath with an open, turned down collar and three-quarter length sleeves. It is possible this dress has been shortened.
Worn and given by Miss Muriel Spark

CASHIN (continued)

374 **Suede shirt dress.** USA. Bonnie Cashin, 1968: the skirt trimmed with Red Indian type fringed trim.
Given by Sills and Co.

375 **Informal suede evening outfit.** USA. Bonnie Cashin, 1970: a beige suede *'happi coat'* with a design of applied blue strips worn with tapering suede *trousers*.
Given by Sills and Co.

OSSIE CLARK (England): Raymond Clark

Born 1942 and studied at Manchester College of Art and the Royal College of Art. He designed his first collection in 1966 for Quorum and is known for his ingenious and nostalgic styling.

376 **Full-length python skin coat.** English. Ossie Clark at Quorum, 1968.

376a **Black dress.** English. Ossie Clark at Quorum, 1971: of crepe trimmed with suede and moon and star embroidery designed by Celia Birtwell.
Given by Mr Ossie Clark

DIOR (continued)

377 **Black faille evening dress.** Christian Dior, about 1955: it has a strapless bodice and a bouffant skirt longer and draped at the back. Originally worn with a matching stole.
Worn and given by Dame Margot Fonteyn

377a **Dark grey evening dress.** French. Christian Dior, 1958: of faille. It is 'princess line' with a low 'V' neck draped to a tie, three-quarter sleeves and a flared skirt. Worn and given by Madame de Courcel

377b **Blue short evening dress.** French. Christian Dior, Autumn/Winter 1959: of faille; with a low round neck trimmed at the centre front with a self bow, three-quarter raglan sleeves and the skirt pleated from a high waist. Worn with matching *shoes* (Maurel, Nice) trimmed with a flat bow, pointed toes and stiletto heels.
Worn and given by Madame de Courcel

377c **Chrysanthemum printed evening dress.** French. Christian Dior, Spring/Summer 1960: with low round neck, three-quarter sleeves and bouffant overskirt trained at the back. In yellow and orange printed silk. Worn with matching *shoes* (Roger Vivier at Christian Dior) with a turned-up toe and high incurving heel.
Worn and given by Madame de Courcel

377d **Dress.** French. Christian Dior, Summer 1964: of white organza trimmed at the hem and at the borders of the wide sleeves with white openwork embroidery.
Worn and given by Mrs Alfred Bloomingdale

377e **White coat.** French. Christian Dior, Spring/Summer 1965: of white cavalry twill with a diagonal 3-button fastening and belt. The edges are surface stitched.
Given by Mr David Watts of Jaeger

FOALE & TUFFIN (England): Marion Foale and Sally Tuffin

Trained at Walthamstow College of Art followed by a period at the Royal College of Art and opened their own dress house in 1962. They are known for their use of a varied range of fabrics, in unusual combinations of garments.

378 **Interchangeable outfit.** English. Foale & Tuffin, 1971: a *blouse* ('little blouse') hip-length and straight cut with long slightly flaring sleeves and *trousers* ('tea-bags') straight cut of blue and white printed wool, with a *pinafore* ('ping-pong') of blue floral printed wool with a quilted high-waisted bodice and tiered gathered skirt and a matching quilted, straight cut, hip-length *jacket* fastening with front ties. Alternate flounces of the skirt and the reverse of the jacket are of the check material. Worn with Japanese type clogs (Elliots).
Given by Foale & Tuffin

GINA FRATINI (England)

Born 1931 in Japan and trained at the Royal College of Art. She began her own dress house in 1966. She is known for her young romantic styling and use of simple yet distinctive fabrics.

379 **Wedding dress.** English. Gina Fratini, 1970: of white organdie trimmed with lace insertion and tucks. The loose top has a frilled lace collar, yoke and bishop sleeves with lace cuffs. The skirt is long, full and slightly trained. Worn with a matching *cap* and *posy* of artificial flowers.
Given by Miss Gina Fratini

GALANOS (continued)

380 **Black chiffon evening dress.** USA. Galanos, Autumn 1969: of finely tucked chiffon embroidered with beaded oval motifs and lined with yellow chiffon. It is a slightly flaring sheath with a high round neck and long slightly full sleeves gathered at the wrist.
Made for Mrs Frederick Brisson (Miss Rosalind Russell) to wear at the première of the musical play 'Coco' at the Mark Hellinger Theatre, New York, 18 December 1969, and given by her

GIVENCHY (continued)

381 **Lily of the Valley evening dress.** French. Givenchy 'Les Muguets' no. 812, 1955: of organdie embroidered all over with a floral design in self-coloured silk, the ground covered with iridescent sequins. The bodice is strapless and the long flared skirt is slightly gathered into the waist and trained.
Worn and given by the Viscountess de Bonchamps

381a **Dress.** French. Givenchy, 1967.
Worn and given by Madame Catao

GRÈS (continued)

382 **White evening dress.** French. Grès, 1955/71: of fine pleated silk jersey with an asymmetrical top with a border arranged in a plaited pattern and a finely pleated skirt.
A design of 1955 reproduced in 1971 specially for this exhibition.
Given by Madame Grès

383 **Grey printed chiffon dress.** French. Grès, 1962. Worn and given by Miss Nancy Mitford

384 **Sequin and velvet evening outfit.** French. Grès, 1965: a *maillot bodice* embroidered with red and blue sequins in a Persian pattern and covered with a full-length black circular *overdress* with high neck and long full sleeves, the curving top of organza and the skirt of velvet.
Given by Madame Grès

385 **Olive green woollen cape.** French. Grès, about 1968–69:
Worn and given by the late Miss Margaret Case

JAMES (continued)

386 **Evening dress.** English. Charles James, about 1935: of grey satin.
Worn by Miss Karen Harris (Mrs Osbert Lancaster) and given by her sister, Miss Honey Harris

386a **Green evening dress.** French. Charles James, 1938–39: of silk printed with a design of masks of Jean Cocteau and Jean Marais designed by Jean Cocteau. The dress has a draped bodice and a skirt which flares widely from the hips.
Given by Mr Charles James

386b **Black and red lamé brocade evening coat.**
French. Charles James, about 1939–40: it has a
standaway yoke and a panelled flaring skirt.
Given by Mr Charles James

387 **Black and white evening dress.** USA.
Charles James, 1953: of white satin and faille with black
velvet appliqué: the bodice is strapless and the skirt very
full.
Ref: This model is also in the Costume Institute, Metro-
politan Museum of New York and was shown in the
exhibition The Art of Fashion 1968, no. 116.
'This design represents the "bringing together" of many
parts from which a whole series of designs had been
made . . . It seemed to me to be somewhat of a thesis and
as such has been programmed as the last design I
intended to make.' Letter from Charles James, *op. cit.*,
1971.
Given by the Art Students League (USA)

ANN KLEIN (USA)

Known for her sportswear and youthful casual designs.

387a **Satin and jersey outfit.** USA. Ann Klein,
1954: A *dress* with a gathered cream satin skirt and grey
knitted sweater top *en suite* with a matching waistlength
cardigan. The *belt* has a paste buckle.
Given by Miss Ann Klein

387b **Black and white outfit.** USA. Ann Klein,
1960: a black linen sleeveless low necked semi-fitted
blouse worn with a flaring *skirt* of white nylon organza
and with a black linen *jacket* with a double breasted
paste button fastening.
Given by Miss Ann Klein

NORELL (continued)

387c **Grey woollen day outfit.** USA. Norman
Norell, Autumn, 1963: a short *jacket* with a black silk
bow at the neck and a round necked short sleeved black
jersey *top* with a grey woollen flared *skirt*.
Given by Norman Norell Inc.

ROBERT PIGUET (France)

Born in 1901 in Yverdon Vaude, Switzerland, Robert
Piguet worked with Redfern and Poiret before opening
his own house in the rue du Cirque. In 1933 he moved to
3 rond point des Champs Elysées. His clothes were
discreet and feminine and his evening clothes known for
their lovely colours. He closed his house before his death
in 1953.

388 **Black net cocktail dress.** French. Robert
Piguet, about 1948: with short sleeves and heart-shaped
neckline and a flared skirt. It is made from black net
covered with vertical bands of applied semi-circular
appliqué frills, mounted on a grey taffeta.
Worn and given by Mrs Frank Wooster

EMILIO PUCCI (Italy):
Count Emilio Pucci

He opened his Florence house about 1944. He is known
for his fine use of colours and the printed fabrics
designed by himself.

389 **Cerise trouser suit.** Italian. Emilio Pucci,
1962-66: of pure silk satin. The *tunic* is slightly flared with
round neck and sleeveless. Fastens down the front with
self-covered buttons. Lined with a hand-printed silk with a
design of flowers and a basket signed 'Emilio', the
trousers are tapered.
Worn and given by Countess Bismarck

389a **Orange trouser suit.** Italian. Emilio Pucci,
1962–66: of pure silk satin. The *tunic* is slightly flared
with round neck and sleeveless, it fastens down the
front with self-covered buttons, and is lined with orange,
green and black semi-abstract and floral design. Worn
with a matching long-sleeved, wide-necked silk jersey
sweater. The *trousers* are tapered.
Worn and given by Countess Bismarck

RHODES (continued)

389b **Evening dress.** English. Zandra Rhodes,
1969: of hand printed chiffon in shades of yellow. It is
full and flowing with a hood.
Worn and given by Mrs Jack Heinz III

ST LAURENT (continued)

390 **Short evening dress.** French. Yves St
Laurent, 1965: of crepe with a black, red and yellow
geometrical design inspired by Mondrian (Peter
Cornelius Mondrian 1872–1944: abstract painter of the
Dutch school). It is a sheath with a round neck and
sleeveless.
Given by Monsieur Yves St Laurent

SCHÖN (continued)

391 **White beaded evening outfit.** Italian. Mila Schön, 1966: a *caftan* of white net with a design of white bead and brilliant rondels, on a bugle-beaded ground, worn over a white crepe strapless *sheath*.
Worn and given by Madame Agnelli

YAMAMOTO (Japan): Kansai Yamamoto

Born 1944 in Yokahama and learned cutting and designing in Tokyo. He became internationally known after his first collection in 1969 and had his first London showing in 1971. He is known for his dramatic and ingenious use of Japanese styles and motifs in a European fashionable context.

392 **Mask patterned culotte suit.** Japanese. Yamamoto, 1971: a full length flared circular gown with high neck made in two vertical halves joined by a central zip. It is entirely covered with a large Japanese mask appliqué.
Given by Mr Kansai Yamamoto

UNATTRIBUTED DRESSES (continued)

393 **Wedding dress.** English. 1922: of silver lamé; a low-waisted *dress* with a lamé *train* from the shoulders edged with silver lace and sequins and a tulle *train* edged with overlapping pale gilt sequins. There is a *belt* of silver sequins, a silk tulle *veil* and orange blossoms and silver *diadem*.
Worn by the Hon Edwina Ashley for her marriage to Lord Louis Mountbatten, at St Margaret's, Westminster, 22 July 1922, and lent by Lord Mountbatten

EXOTIC FANCY AND THEATRICAL DRESS

393a **Costume 'Clair de Lune'.** French. Erté, 1922: *top*, draped *trousers* and ostrich feather trimmed turban type *head-dress* of silver lamé decorated with pearls. 'At the Ball only white silk or white velvet costumes were allowed. Mine was entirely made of *lamé d'argent*, ornamented with a multitude of pearls. I christened it 'Clair de Lune', as in this costume there is nothing oriental but my own imagination. The first prize was awarded to 'Clair de Lune' . . .' Erté's own account of the costume from *Harpers Bazaar*, June 1922, quoted in C. Spencer, *Erté*, London 1970, p. 187. A photograph of Erté wearing the costume is reproduced on pl. 59.
Given by Erté

MEN'S CLOTHES (continued)

394 **City suit.** English. Leslie and Roberts, 1929: a black double breasted *jacket* and beige hop sack *waistcoat* (Pleydell & Smith) worn with a cream silk *shirt* (Rochester) an Oundle *tie* and a *bowler hat* (Lock & Co.) worn with striped trousers.
Worn and given by Aubrey Esson-Scott

395 **Sports outfit.** English. 'Carefree' about 1929: white *shirt* with woollen welt and white flannel *trousers*. Worn for punting by Mr Aubrey Esson-Scott (World Punting Champion 1929–34) with Thames Punting Club blazer and cravat, white shorts with turn ups and two tone shoes and given by him

396 **Hunting suit.** English. Huntsman & Sons, 1930s: in black and white shepherd's check tweed. The *acket* has leather yoke and green faced collar and is worn with matching *breeches* and a green *waistcoat* with gilt buttons, pale lovat green woollen *shirt* (Turnbull & Asser) a black and white spotted *cravat* and a *cravat pin* with a stags tooth mount (A D Hauptmann & Co., Vienna), scarlet flannel *braces* (Thurston) and *riding boots*.
Worn by Mr Aubrey Esson-Scott for stag hunting, hacking and shooting and given by him

397 **Tropical dinner jacket.** English. Anderson & Shepherd, 1930: and white *waistcoat* (Morgan & Ball).
Worn and given by Mr Aubrey Esson-Scott

398 **Morning suit.** English. 1931: the *coat* (Leslie & Roberts) of soft black saxony worn with striped *trousers* (Pleydell & Smith), black satin *cravat* (Morgan & Ball), grey *top hat* (Lock & Co), *cigar* and *note-case* (C. Cartier) and *eye glass*.
Worn and given by Mr Aubrey Esson-Scott

399 **Overcoat.** English. Pleydell & Smith, 1931: for day or evening: of black velour; double breasted with half belt.
Worn and given by Mr Aubrey Esson-Scott

400 **Lounge suit.** English. Ward & Co., 1932: of blue and white diagonally striped worsted. It is double breasted. Worn with a black and white striped *shirt* (Morgan & Ball) and a black satin *tie* with a pearl *cravat pin* (Cartier) and black *shoes* (Fortnum & Mason) and with a cream silk *handkerchief* in the breast pocket.
Worn and given by Mr Aubrey Esson-Scott

401 **Dress suit.** English. Anderson & Shepherd, 1933: of midnight blue barathea. Worn with a pique *waistcoat* (Hawkes & Curtis), stiff fronted *shirt* and *collar* (Morgan & Ball), white *tie* black satin monogrammed *braces* (Thurston), black silk *top hat* (Lock & Co), and black patent *evening pumps*. The *cuff links* of diamond and onyx and evening *pocket watch* of chrome and black leather with seed pearl and chrome chain, the *spectacle case* with monogram designed by Baron Max Fould-Springer are from Cartier; the *money clip* (1952) and gold *tooth-pick* (1934) from Asprey.
Worn and given by Mr Aubrey Esson-Scott

402 **Buff check suit.** Bermuda. Trimingham, 1940.
Worn and given by His Royal Highness the Duke of Windsor

BLADES (England): Rupert Lycett Green

Opened in Dover Street in 1962, by Rupert Lycett Green to carry out his new less severe concept in bespoke tailoring. In 1966 it moved to Burlington Gardens. Known for its imaginative manipulation of conventional men's styling.

403 **Cream silk brocade suit.** English. Blades, 1968: straight cut collarless fly fronted *jacket* and straight cut *trousers*, worn with a matching natural silk *shirt* with a scarf tie collar. The brocade is of mid-19th century type design rewoven in 1953 in Lyons: only 100 yards were made.
Worn and given by Mr Rupert Lycett Green

404 **'Kipper' tie.** English. Mr Fish, 1966–67: in a satin weave silk, hand-printed in purple, orange and white, with a 1920s reproduction design.
Worn and lent by Mr Quentin Crew

405 **Black evening outfit.** English. Mr Fish, 1969–70: The top is of black velvet, loose fitting with full sleeves fitted at the cuffs. It has a v-neck with turned down half-collar, and two waist pockets with scalloped flaps. The *trousers* are fitted and made from a lightweight black rayon with a satin stripe on the side seams.
Worn and given by the Earl of Lichfield

406 **Blue jeans outfit.** USA. 1970–71: a pair of blue cotton *jeans* (Levi Strauss & Co) with matching waist-length *jacket* (Lee), a yellow cotton short-sleeved *t-shirt* (BVD), red and white and lilac and white printed *scarves*, a black leather *belt* and a pair of white wool and nylon *socks* (Burlington Adler), and white canvas *shoes* (Admiral).
Worn and given by Mr Robert Lavine

HATS & HEAD-DRESSES (continued)

407 **Bird of Paradise mount.** French. About 1910: copied from one worn by the Marchese Casati.
Worn and given by Mrs Frank Wooster

408 **Feather bandeau.** French. About 1915: with diamanté centre trimmed with bird of paradise plumes.
Worn and given by Mrs Frank Wooster

409 **Hair decoration.** French. About 1915: of blue and brilliant paste trimmed with blue ospreys.
Worn and given by Mrs Frank Wooster

410 **Gold lace osprey trimmed cap.** French. About 1920.
Worn and given by Mrs Frank Wooster

411 **Black beret.** English. 'Beret Sport', about 1933: of fur felt.
Worn and given by Mrs William King

412 **Bluebird hat.** French. Caroline Reboux, about 1934: a tip-tilted cap entirely covered with blue feathers with a flying bluebird mount.
Worn and given by Mrs Frank Wooster

412a **Black grosgrain hat.** English. Charles James, 1936: a flat cap made from a single unseamed but twisted piece of material.
Worn and given by Miss Philippa Barnes

413 **Blue straw hat.** French. Schiaparelli, 1938: with wide flat brim and hollowed crown. Originally to be worn over a sprigged cotton kerchief tied peasant style.
Worn by Lady Frieda Valentine at Ascot 1938 and given by her

414 **Pink and black feather hat.** French. Caroline Reboux, about 1938: a tip tilted toque.
Worn and given by Mrs Frank Wooster

415 **Tricorne hat and cape.** USA. About 1938.
Worn and given by Miss Marianne Moore

416 **Blue ostrich trimmed hat.** French. Caroline Reboux, about 1938: of black satin trimmed with a panache of blue ostrich feathers.
Worn and given by Mrs Frank Wooster

417 **Green velvet hat.** USA. Braagaart Inc. About 1941: tiny tip tilted and trimmed with green tipped feathers and a green and pink velvet bow.
Worn and given by Mrs Frank Wooster

418 **Green toque.** USA. Przeworska, 1946: trimmed with silver-green ribbon.
Worn and given by Mrs William King

419 Peacock feather trimmed hat and gloves.
French. Caroline Reboux, 1946: a cap of suede with a
pointed band, edged with peacock feathers, trimmed
centrally with a peacock crest. The *gloves* are of black
suede trimmed at the cuffs with peacock feathers.
Worn and given by Ava, Lady Waverley

420 Green felt beret trimmed with mink. English.
Madame Vernier, 1947.
Worn by Princess Marina, Duchess of Kent and given by
Madame Vernier

421 Black suede and osprey hat. French. Caroline
Reboux, 1947: a tip-tilted cap trimmed with osprey
plumes.
Worn and given by Mrs Frank Wooster

422 Black halo hat. French/English, about 1950:
of velvet.
Worn and given by Mrs William King

423 White straw hat. English. Madame Vernier,
1952.
Worn by Princess Marina, Duchess of Kent for her first
tour of the Far East, and given by Madame Vernier

424 White and Black straw cap. English/French.
Halina Kirn, 1950–55: trimmed with black jet beads and
velvet ribbon.
Worn and given by Mrs William King

424a Navy blue straw hat trimmed with organza.
French. Mizza Bricard at Christian Dior, about 1960.
Worn and given by Madame de Courcel

424b Quail feather toque. French. Mizza Bricard
at Christian Dior, about 1960.
Worn and given by Madame de Courcel

**425 Navy-blue and white ostrich feather trimmed
hat.** English. Madame Vernier, 1967–68.
Worn by Princess Marina, Duchess of Kent, for Ascot and
given by Madame Vernier

426 Cerise ostrich frond cap. French. Givenchy,
about 1967: trimmed with a curled matching plume.
Intended to be worn over a chignon.
Worn and given by Mrs Pierre Schlumberger

426a Pink and black ostrich feather hat. French.
Mizza Bricard at Christian Dior, about 1967.
Worn and given by Madame de Courcel

426b Water lily trimmed hat. French. Mizza
Bricard at Christian Dior, about 1968.
Worn and given by Madame de Courcel

SHOES (continued)

426c Red velvet shoe. French. Yanturni, about
1910: of crimson velvet embroidered in gilt thread with a
formal floral design. It has a strap with diamanté buckle
over a high tongued front, pointed toe and medium heel.
Worn and given by Mrs C. G. Lancaster, who gave them
to the Museum and Art Gallery, Northampton, by whom
they are lent

426d Black tulle over satin shoe. French. Roger
Vivier for Christian Dior, 1954: trimmed with a frill of
black tulle. It has a high 'spike 'heel and a long squared-
off pointed toe. Example of the first 'aiguille' heel made
in 1954 for Christian Dior (Information from Monsieur
Roger Vivier).
Given by Monsieur Roger Vivier

426e Pink beaded evening shoe. French. Roger
Vivier at Christian Dior, 1959: embroidered with coral
beads, silver and brilliants. It has a turned-up toe and a
small rounded and curved heel. Model made for 'practically
all very elegant clients' (Information from Monsieur
Roger Vivier).
Given by Monsieur Roger Vivier

426f Black patent silver-buckled shoe. French.
Roger Vivier, 1963: with square toe. 'Made for the first
time for Baroness Pauline de Rothschild and were later
copied all over the world' (Information from Monsieur
Roger Vivier).
Given by Monsieur Roger Vivier

426g Pink beaded evening shoe. French. Roger
Vivier, 1965: embroidered with pink shell beads and
steel pendant sequin shapes. It has a pointed toe and an
incurving square facetted heel. 'This model was first
made for H.M. the Empress of Iran' (Information from
Monsieur Roger Vivier).
Given by Monsieur Roger Vivier

ACCESSORIES (continued)

427 Artificial flowers. French. Mesdames
Lespiaut, 1930s.
Used and given by Mrs Frank Wooster

427a Red and green beaded bandeau. French.
Schiaparelli, 1938.
Used and given by Lady Frieda Valentine

428 **Black butterfly cape.** USA. Matilda Etches, 1951: a circle of finely pleated pure silk taffeta, which can be worn in a variety of ways.

The design was based on one made for Dame Ninette de Valois in 1949, of which a version in red and black ribbon is in the Victoria and Albert Museum Department of Textiles (T.185-1969) together with the toile and US Original Design Letters Patent 169,670, 1953. Also in the Department of Textiles are Matilda Etches' press cuttings books and several dresses designed by her.
Worn and given by Mrs Homan (Miss Matilda Etches)

428a **Gilt deerhorn trimmed combs.** French. Schiaparelli, 1935.
Used and given by Lady Frieda Valentine

429 **Lilac ostrich feather fan.** French. About 1900: with blonde tortoise-shell sticks.
Used and given by Mrs Frank Wooster

430 **King-fisher feather fan.** Viennese, about 1905: with blonde tortoise-shell sticks and 'Mitzy' inlaid in gold on the guard.
Designed and given by Mrs Frank Wooster

431 **Shaded pink ostrich feather fan.** English or French. 1920s: with tortoise-shell sticks.
Used by Lady Mountbatten and lent by Lord Mountbatten

432 **Beige ostrich feather fan.** English or French. 1920s: with mother-of-pearl sticks.
Used by Lady Mountbatten and lent by Lord Mountbatten

433 **White ostrich feather fan.** English or French. 1920s: with blonde tortoise-shell sticks.
Used by Lady Mountbatten and lent by Lord Mountbatten

434 **Cerise ostrich feather fan.** English or French. 1920s: with tortoise-shell sticks.
Used by Lady Mountbatten and lent by Lord Mountbatten

435 **Pale orange ostrich feather fan.** English or French. 1920s: with tortoise-shell sticks.
Used by Lady Mountbatten and lent by Lord Mountbatten

436 **Mauve ostrich feather fan.** English or French. 1920s: with tortoise-shell sticks.
Used by Lady Mountbatten and lent by Lord Mountbatten

437 **Pink and white ostrich feathered fan.** English or French. 1920s: with mother-of-pearl sticks.
Used by Lady Mountbatten and lent by Lord Mountbatten

438 **Green ostrich feather fan.** English or French. 1920s: with tortoise-shell sticks.
Used by Lady Mountbatten and lent by Lord Mountbatten

439 **Pink ostrich feather fan.** English or French. 1920s: with pale tortoise-shell sticks.
Used by Lady Mountbatten and lent by Lord Mountbatten

440 **Apricot ostrich feather fan.** English or French. 1920s: with pale tortoise-shell sticks.
Used by Lady Mountbatten and lent by Lord Mountbatten

441 **Handkerchief.** French. About 1870: white-work embroidered and with bobbin-lace border and monogram 'S' with coronet in corner.
It belonged to Baroness Gustave de Springer, née Helene de Koenigswarter, and was given by her daughter, Mrs Frank Wooster

442 **Handkerchief.** French. About 1870: of lawn with a bobbin-lace border.
It belonged to Baroness Gustave de Springer, née Helene de Koenigswarter, and was given by her daughter, Mrs Frank Wooster

443 **White lamb jacket.** English. About 1928: waist-length with lapels and metal buttons.
Worn by Lady Mountbatten and lent by Lord Mountbatten

444 **Cream parasol.** Vienesse. Karl Heiss, about 1890: with looped braid border. It has a long tapering handle of blonde tortoise-shell studded with pastes.
Used and given by Mrs Frank Wooster

445 **Black satin parasol.** French. About 1905: with tiered flounces and a border of black organza. It has a long crop handle of gilt metal studded with diamonds and rubies.
Used at Ascot 1905, and given by Mrs Frank Wooster

446 **White lace tunic.** French. About 1966–68: of open-work embroidery. It is straight cut with a round neck and short sleeves.
Worn and given by Countess Bismarck

447 **Black enamelled vanity case.** French. Cartier, about 1935–36.
Used and given by Lady Frieda Valentine

Bibliography

Adburgham, A. *A view of fashion*. 1966

Amies, H. *Just so far*. 1954

Ballard, B. *In my fashion*. 1960

Balmain, P. *My years and seasons*. Trans. E. Lanchbery with G. Young. 1964

Beaton, C. *Scrapbook*. 1937

Beaton, C. *Time exposure*. 1941

Beaton, C. *Photobiography*. 1951

Beaton, C. *The glass of fashion*. 1954

Beaton, C. *Cecil Beaton's diaries (the wandering years)*. 1961

Beaton, C. *Cecil Beaton's diaries (the years between)*. 1965

Beaton, C. *The best of Beaton*. 1970

Beaton, C. *My Bolivian Aunt*. 1971

Bertin, C. *Paris à la mode. A voyage of discovery*. Trans. M. Deans. 1956

Brogden, J. *Fashion design*. 1971

Brooklyn Museum. *The house of Worth*. 1962

Chase, E. W., and Chase, I. *Always in 'Vogue*. 1954

Chillingworth, J., and Busby, H. *Fashion*. 1961

Crawford, M. D. C. *The ways of fashion*. 1941

Dariaux, G. A. *Elegance*. 1964

Dior, C. *Dior by Dior*. Trans. A. Fraser. Weidenfeld & Nicolson, 1957. Penguin Books, 1958.

Fairchild, J. *The fashionable savages*. 1965

Garland, A. *The lion's share*. 1970

Garland, M. *Fashion*. 1962

Ginsburg, M. 'The making and distribution of clothes' in *Costume Society Spring Conference 1967*, pp. 14–22

Ginsburg, M. 'Clothing manufacture 1860–90' in *Costume Society Spring Conference 1968*, pp. 2–10

Gordon, L. W. D. *Discretions and indiscretions*. 1932

Halliday, L. *The fashion makers*. 1966

Hartnell, N. *Silver and gold*. 1955

Henry, Mrs R. *This feminine world*. 1956

Latour, A. *Kings of fashion*. 1958

Los Angeles County Museum. *A remembrance of Mariano Fortuny 1871–1945*. 1967–68

Metropolitan Museum of Art, New York. *The art of fashion*. (Exhibition catalogue.) 1968

Metropolitan Museum of Art, New York. *Fashion, art and beauty*. 1968

Musée du Costume de la Ville de Paris. *Grands couturiers parisiens, 1910–1939*. December 1965–April 1966

Picken, M. B., and Muller, D. L. *Dressmakers of France: the who, how and why of French couture*. 1956

Poiret, P. *En habillant l'époque*. 1930

Poiret, P. *King of fashion, the autobiography of Paul Poiret*. Trans. S. H. Guest. 1931

Rochas, M. *Vingt-cinq ans d'élégance à Paris*. 1951

Saunders, E. *The age of Worth, couturier to the Empress Eugénie*. 1954

Schiaparelli, E. *Shocking life*. 1954

Spanier, G. *It isn't all mink*. 1959

Thaarup, A. *Heads and tales*. 1956

Vogue. The world in Vogue. 1963

Vogue. New Vogue sewing book. 1964

Wilcox, R. T. *The dictionary of costume*. 1969

Williams, B. *Fashion is our business*. 1938

Worth, J. P. *A century of fashion*. 1928

Plates

1 The Duchess of Portland as the Duchess of Savoia, 1897. Cat. 255. Photo from private collection
2 Evening dress by Fortuny, about 1912. Cat. 96
3 Velvet cloak, about 1915. Cat. 171
4 Sybil, Marchioness of Cholmondeley in her Vionnet dress, 1920. Cat. 246. Photo from private collection
5 Evening dress by Callot, about 1922. Cat. 40
6 Evening dress by Charles James, 1934. Cat. 159
7 Trouser suit by Chanel, 1937/38. Cat. 50
8a Hat, jacket and necklace by Schiaparelli, 1937/38. Cat. 274, 226, 355
8b 'Cravat' sweater by Schiaparelli, 1928. Cat. 219
9a The Duchess of Windsor in her Mainbocher jacket, 1938. Cat. 174
9b Evening dress by Mainbocher, c. 1936. Cat. 173
10 New Look cocktail dress by Dior, 1947. Cat. 67
11 Audrey Hepburn in Ascot dress from 'My Fair Lady', 1963. Cat. 258a
12a Evening dress by Schiaparelli, 1953. Cat. 227
12b Evening dress by Balenciaga, 1962. Cat. 19
13a Evening coat and trousers by Balenciaga, 1960. Cat. 10
13b Evening coat by Balenciaga, 1960. Cat. 10
14 Evening dress by Balenciaga, 1967. Cat. 27
15 Evening dress and cape by Balenciaga, 1967. Cat. 27

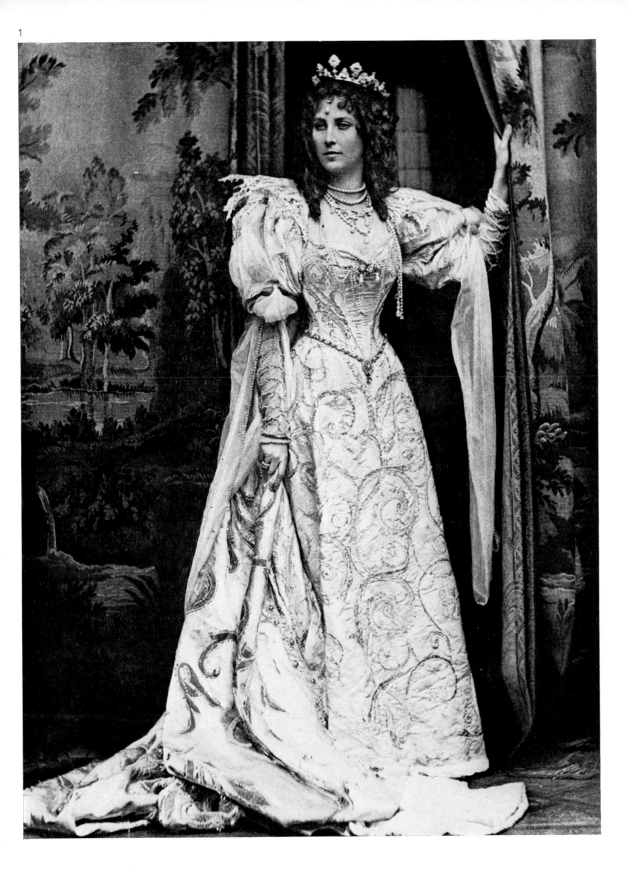

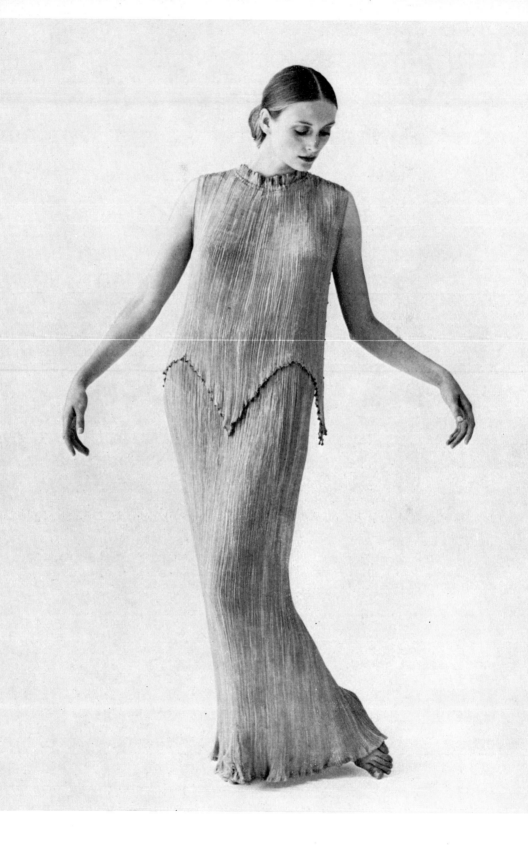

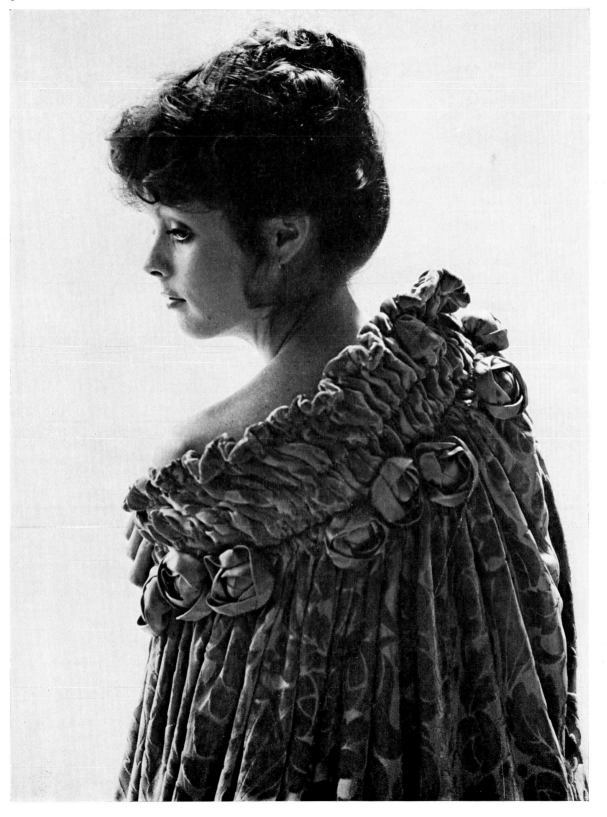

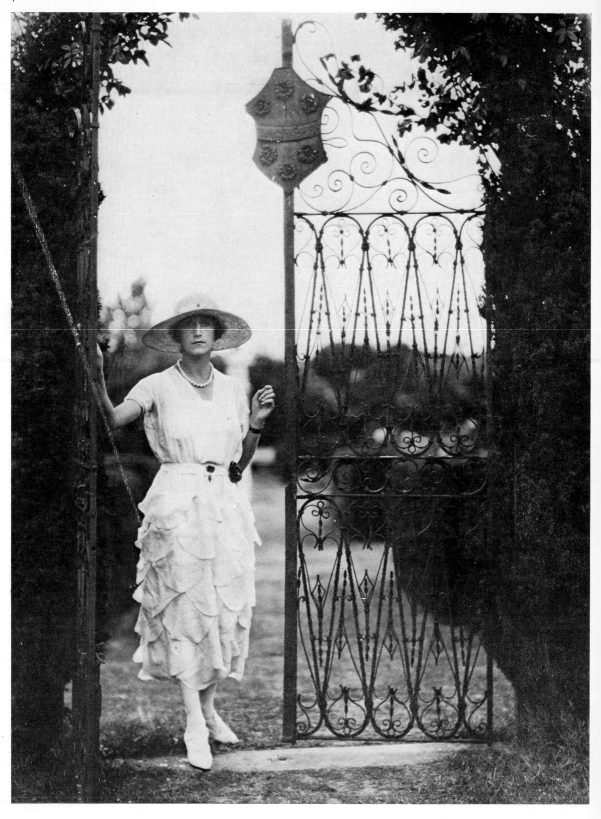

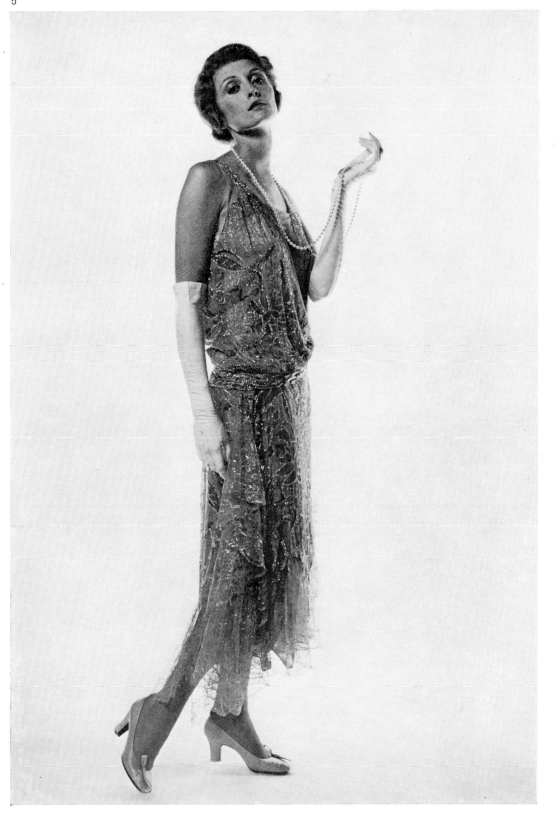

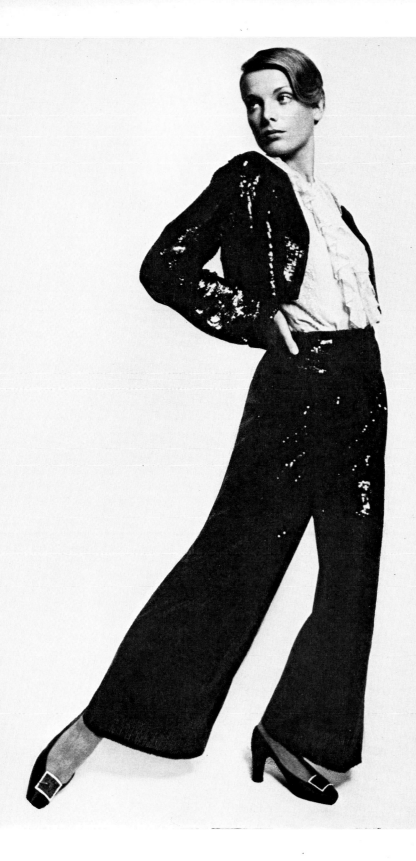

8a

8b

9a

9b

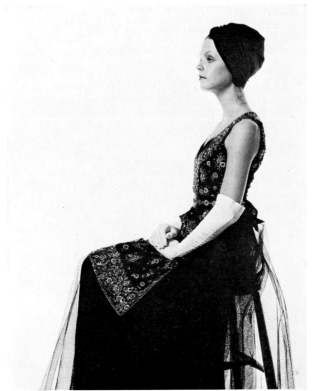

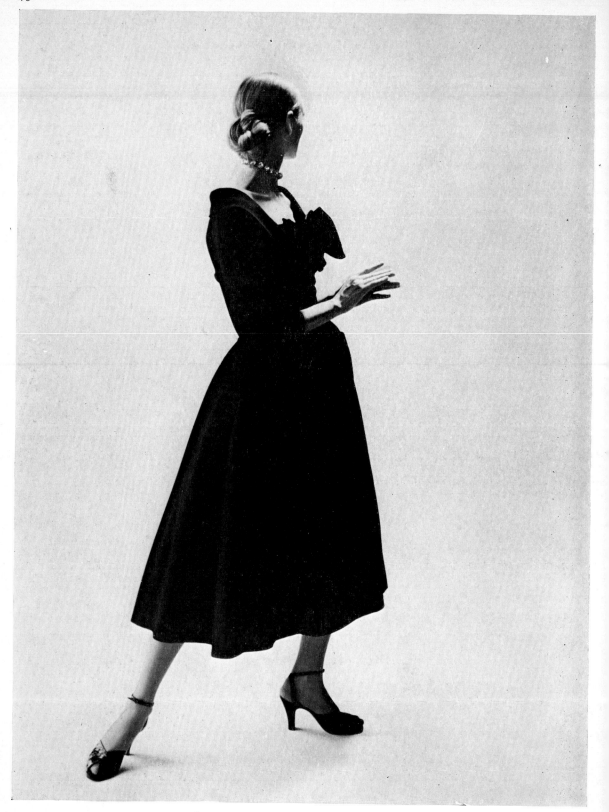

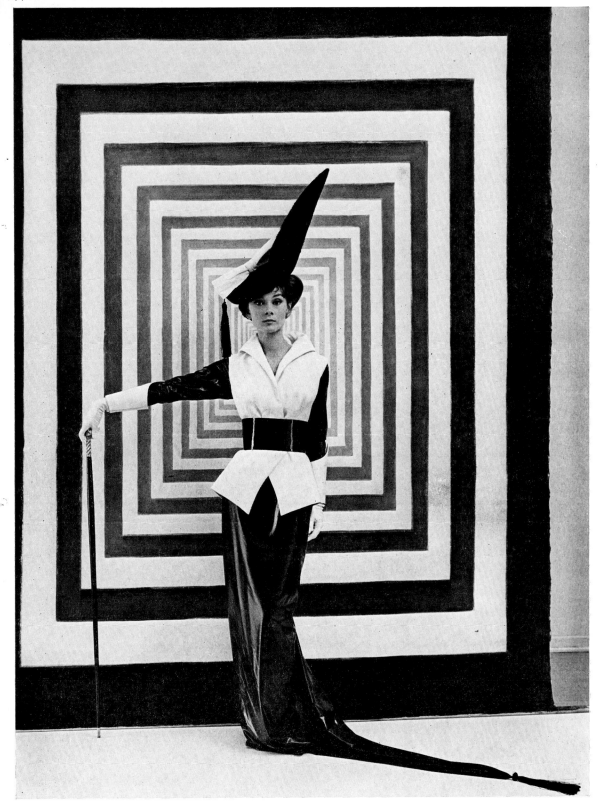

12a

12b

13a

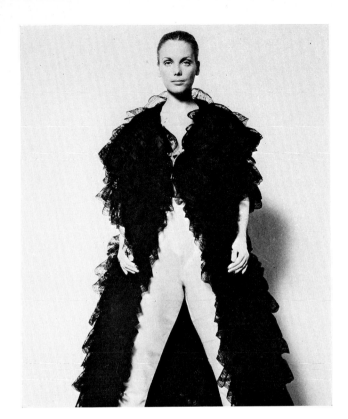

13b

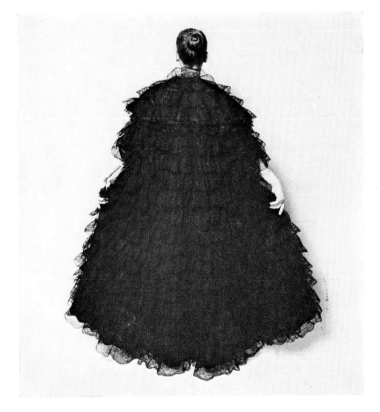

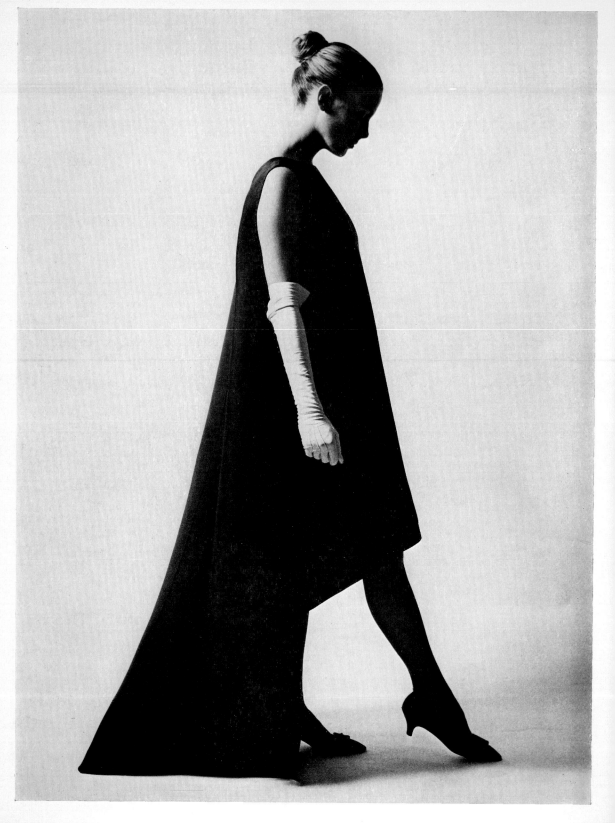

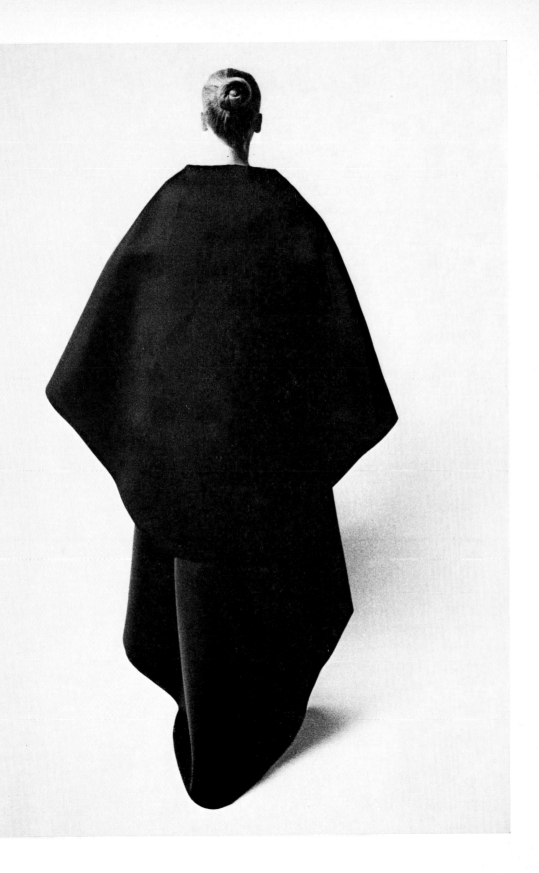

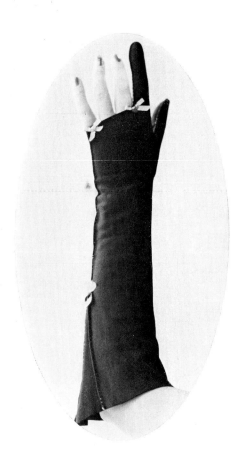

Glove by Appin, *c.* 1938. Cat. 351